Adirondack Moments

James Kraus

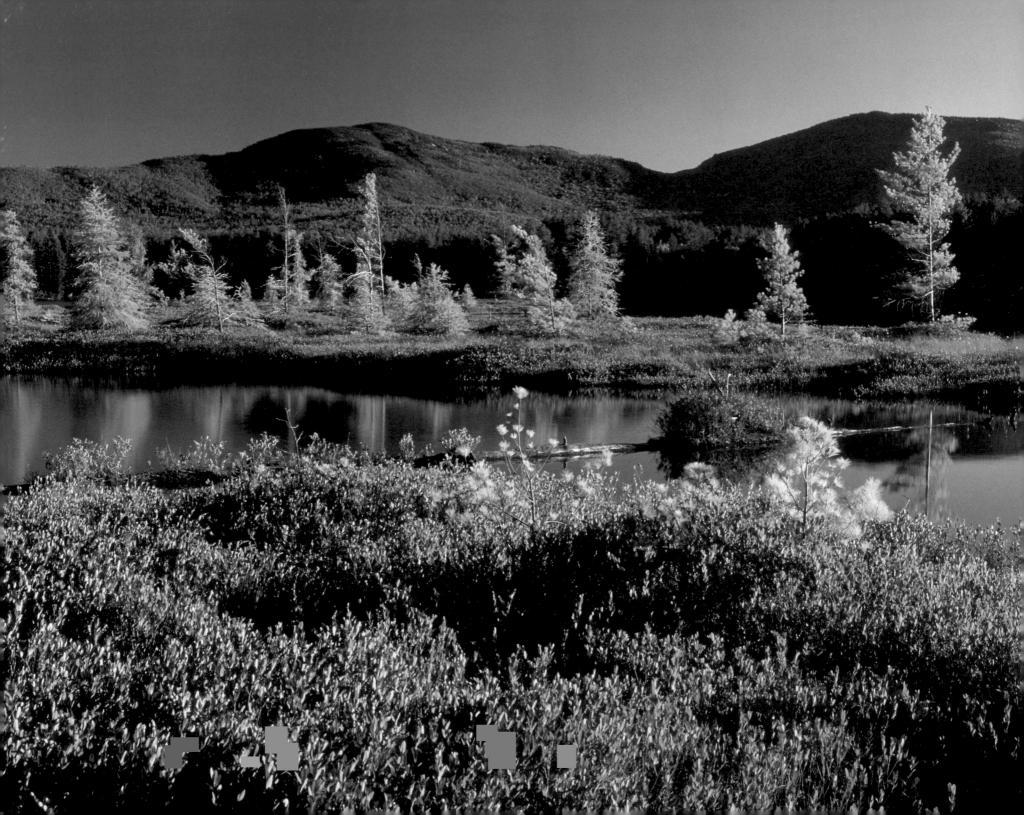

Adirondack Moments

James Kraus

FIREFLY BOOKS

A FIREFLY BOOK

Published by Firefly Books Ltd. 2009

First printing

Publisher Cataloging-in-Publication Data (U.S.)

Kraus, James.
 Adirondack moments / James Kraus.
[132] p. : col. photos. ; cm.
Includes index.
Summary: Photographs from the collection of James Kraus, which express a deep connection to the natural elements of the Adirondack mountains.
ISBN-13: 978-1-55407-466-2
ISBN-10: 1-55407-466-5
1. Adirondack Mountains Region (N.Y.)—Pictorial works. 2. Landscape—New York (State)—Adirondack Mountains Region—Pictorial works.
3. Photographers—New York (State)—Adirondack Mountains—Biography.
I. Title.
974.7/5041 dc22 F127.A2K738 2009

Library and Archives Canada Cataloguing in Publication

Kraus, James
 Adirondack moments / James Kraus.
ISBN-13: 978-1-55407-466-2
ISBN-10: 1-55407-466-5
 1. Natural history—New York (State)—Adirondack Park—Pictorial works. 2. Landscape—New York (State)—Adirondack Park—Pictorial works. 3. Adirondack Park (N.Y.)—Pictorial works.
4. Adirondack Mountains (N.Y.)—Pictorial works. I. Title.
F127.A2K73 2009 508.747'50222 C2009-901026-7

Published in the United States by
Firefly Books (U.S.) Inc.
P.O. Box 1338, Ellicott Station
Buffalo, New York 14205

Published in Canada by
Firefly Books Ltd.
66 Leek Crescent
Richmond Hill, Ontario L4B 1H1

Cover Design: Erin R. Holmes/Soplari Design
Interior Design and layout: Janette Thompson/Jansom

Printed in China

The publisher gratefully acknowledges the financial support for our publishing program by the Government of Canada through the Book Publishing Industry Development Program.

35935904 10·09

Dedicated to:

Annie

David & Delia

Shannon & Dave

My Grandchildren

and

My students at Paul Smith's College

Contents

Introduction

*"Each moment of the year has its own beauty … a picture which was
never before and shall never be seen again."* – Ralph Waldo Emerson

ADIRONDACK PARK

The Adirondack Park was created by the State of New York in 1892 out of a concern for the region's water and timber resources. This six million acre park, a mix of public and private land, is larger than Yellowstone, Everglades, Glacier and Grand Canyon National Parks combined. Within this region are 3,000 lakes, 30,000 miles of streams and rivers, 46 peaks over 4,000 feet in elevation, and a wide variety of habitats including wetlands and old-growth forests.

The public land makes up close to half of the park and is constitutionally protected to remain "forever wild." Trails, campgrounds and other recreational facilities are found on this land. The private land includes villages and towns, timberlands, farms, recreational development and private homes.

The Adirondack Park State Master Plan sets policy for the management of the state-owned lands. Policy on the private land is governed by the Adirondack Park Land Use and Development Plan and is designed to conserve the park's natural features and open-space character by directing and clustering development to minimize its impact on the park.

ADIRONDACK MOMENTS

Over the years I have concluded that moments are dramatic gems of fleeting beauty which materialize from the workings of natural processes. The why, how, when and where of moments are a part of nature's mystery, not easily explained or understood. Human senses have the ability to tell us they are there. Our minds and hearts allow us to ponder their presence.

In *The Singing Wilderness*, author and environmentalist Sigurd Olson compares the experience of moments to the beauty of music. He writes, "I have heard it on misty migration nights when the dark has been alive with the high calling of birds, and in the rapids when the air is full of their rushing thunder. I have caught it at dawn when the mists were moving out of the bays, and on cold winter nights when the stars seem close enough to touch."

The music of moments uses a variety of instruments to express ranges and intensities. The elegance of a flute compares to the finesse of a single wildflower. A harp communicates the delicacy of ice ferns on a window pane. But only an orchestra can capture a panoramic sweep of forests, lakes and mountains across a horizon.

I enjoy all Adirondack moments, but most of my searching is for visual moments, which I try to photograph. As I hike, canoe and travel in the Adirondacks, I am always looking for potential subjects. When I climb a mountain I check the views and compass directions to determine if a good photograph might occur at sunrise or sunset. I see an island in a lake and decide to be there at dawn. I ski through a forest and wonder if it will be filled with wildflowers in spring. The search never ends.

People have always gone to the north woods in search of inspiration that will provide refreshment to body, mind and spirit. Many search for trout streams, hiking trails or campsites. Others search for mountain views, misty lakes or dewdrops caught in the wings of a dragonfly. A few search for the meaning and purpose of life. To go to the woods is to search.

Searching makes us aware of our lost connections to the earth and the ancient rhythms that stimulated and governed native peoples for thousands of years. Although we no longer have vast wilderness areas available, we do have places like the Adirondacks. If we protect and treasure these places, moments of natural beauty can be an important part of our lives.

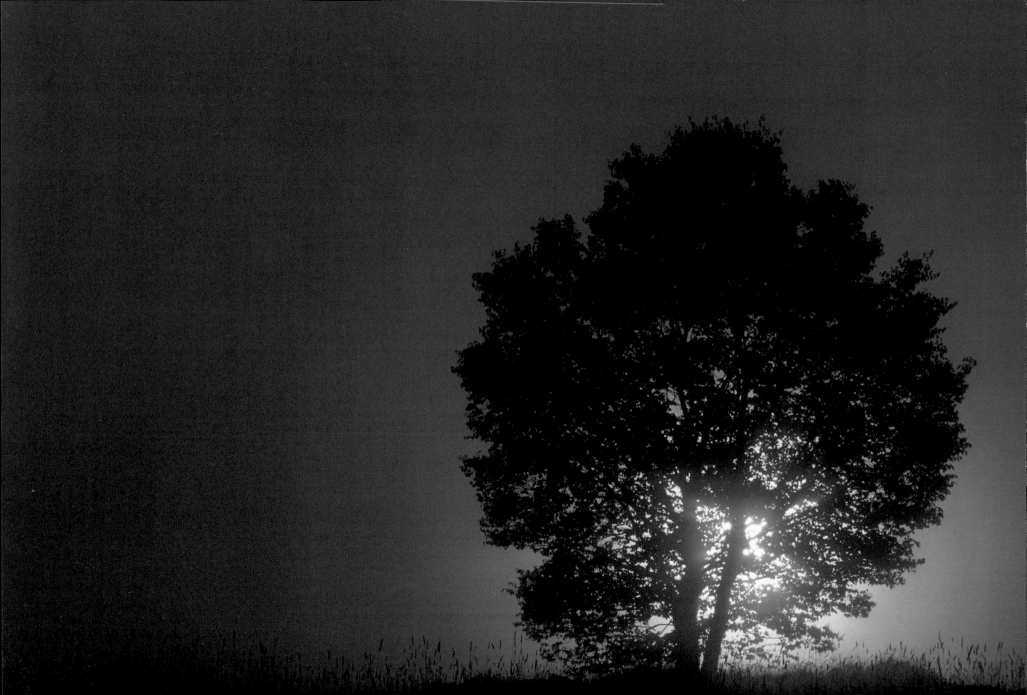

Light

Many of the great painters from the Hudson River School knew how to capture the essence of light in their Adirondack and Catskill paintings. Major themes showed dark clouds parting over mountains with rays of sunlight falling on a lake or pastoral valley below.

Frequently, their paintings contrasted the powerful edges of light and darkness as they used clouds, mist and sun to create sublime landscapes that stimulated many to appreciate nature's beauty. Ralph Waldo Emerson wrote, "Light is the first painter, and the edge is the best of artists."

Photographers followed painters in their search for light. Because the camera was a more believable medium for communicating light and landscape, people were more willing to accept what they saw in a photograph as being real.

Ansel Adams was one of the first photographers to seek dramatic light in his landscape photographs, which stand as mileposts of excellence to all who search for light's moment. In his book, Natural Light Photography, Adams wrote, "Light . . . is as much of an actuality as rock or flesh, it is an element to be evaluated and interpreted."

Dramatic light occurs most often in early morning or late evening, when the sun sends low, slanting rays across the land. It can also occur at midday, when scudding clouds flirt with the sun, or just before or after a storm. During these times, clouds and terrain intercept and scatter sunbeams into beautiful arrangements of highlights, shadows and colors.

I have chased light across lakes, up mountains and along highways. Some of these races ended with excellent photographs. Others concluded before I could set up my tripod.

Winter, spring and summer have moments when dramatic light falls on the land, but autumn is my favorite season. In fall, the sun is lower in the sky, the air has less humidity and the Adirondacks are filled with vibrant colors to amplify the light's intensity. Photographs are everywhere in autumn light.

My search for light often starts with a weather forecast that has the potential for a spectacular sunrise. On such mornings there might be several hundred moments created by light. The challenge is to find them. The best place is one that has the promise for dramatic light to fall on a worthy subject. There are no guarantees in the game of chasing light.

Facing Page: Dawn sets a gray birch in a field ablaze, near Paul Smiths.
Spectacular light has the power to transform subject and landscape, but it can be fickle and erratic.

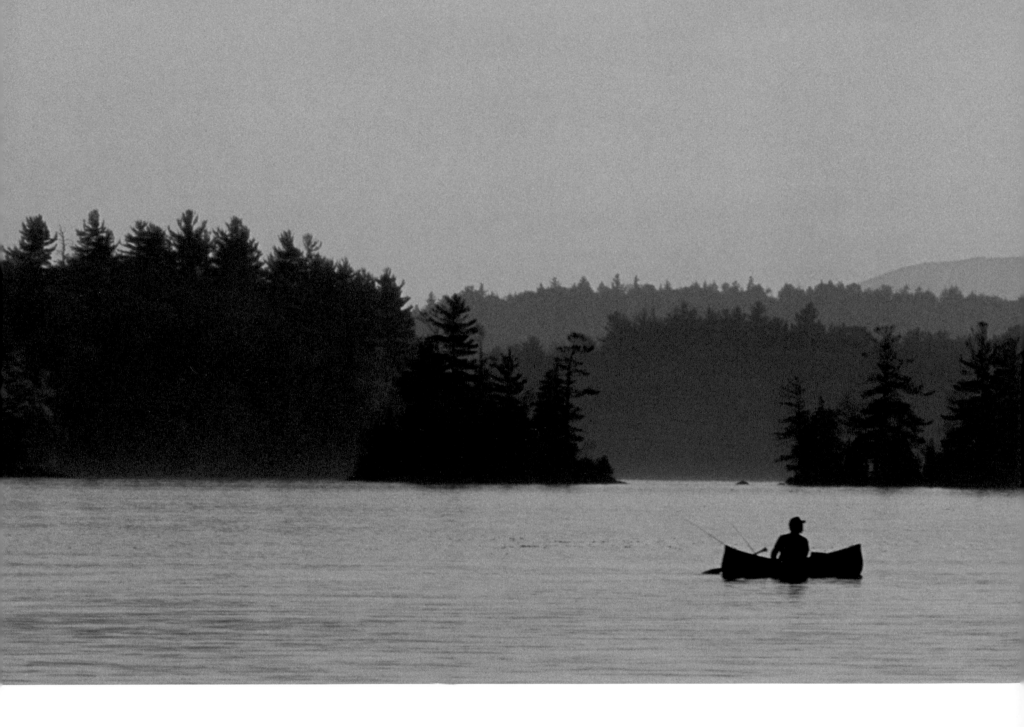

A fisherman paddles his canoe on Saranac Lake at dusk.

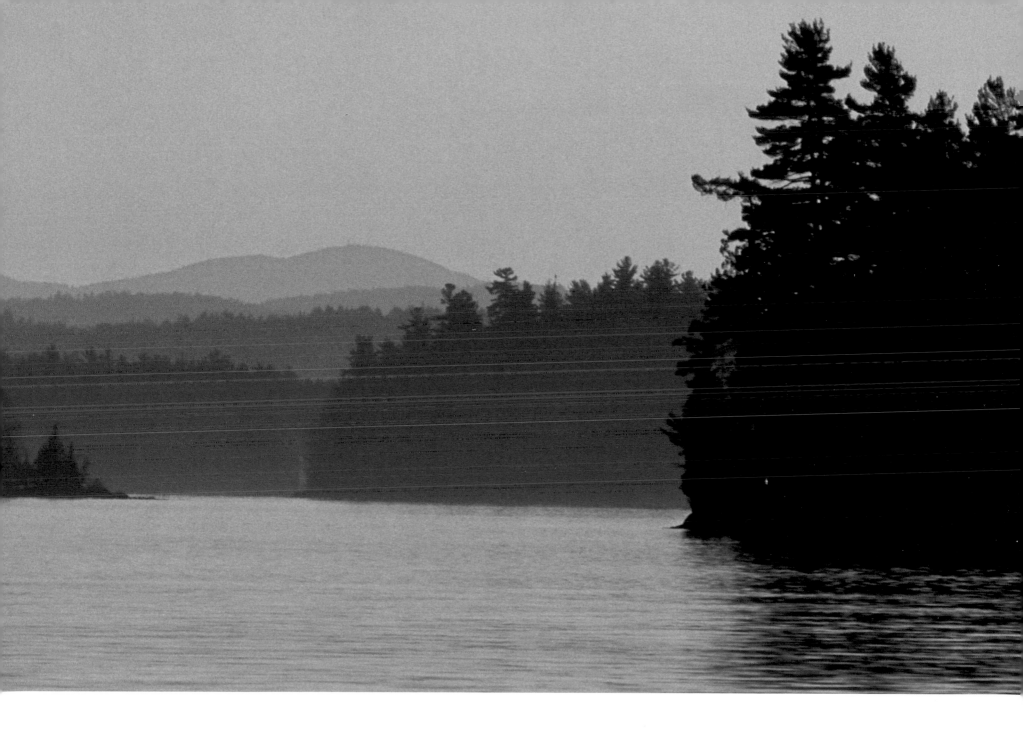

There is a beautiful marriage of mountain and lake in the Adirondacks. Climb a mountain and you see a lake.
Canoe a lake or pond and you see a peak.

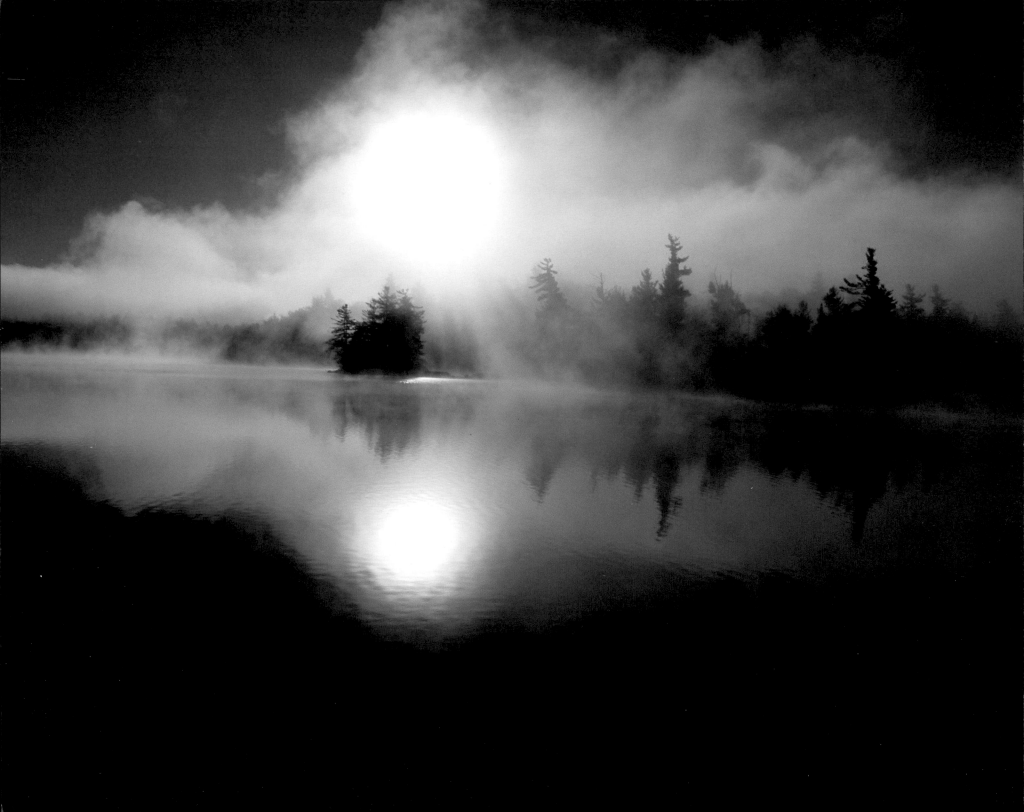

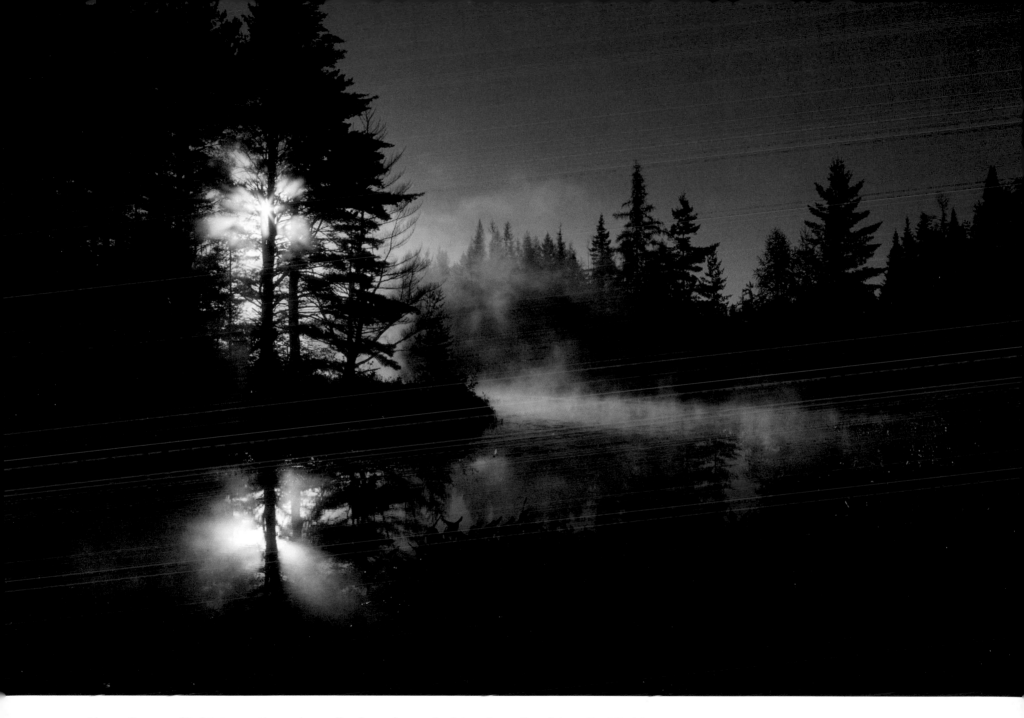

Above: Beams of light stream through needles, branches and mist on Jones Pond, near Paul Smiths.

Facing Page: Mist and dawn over islands – Franklin Falls Pond, near Vermontville.

The mist and fog off a lake will roll, curl and rise like white smoke.

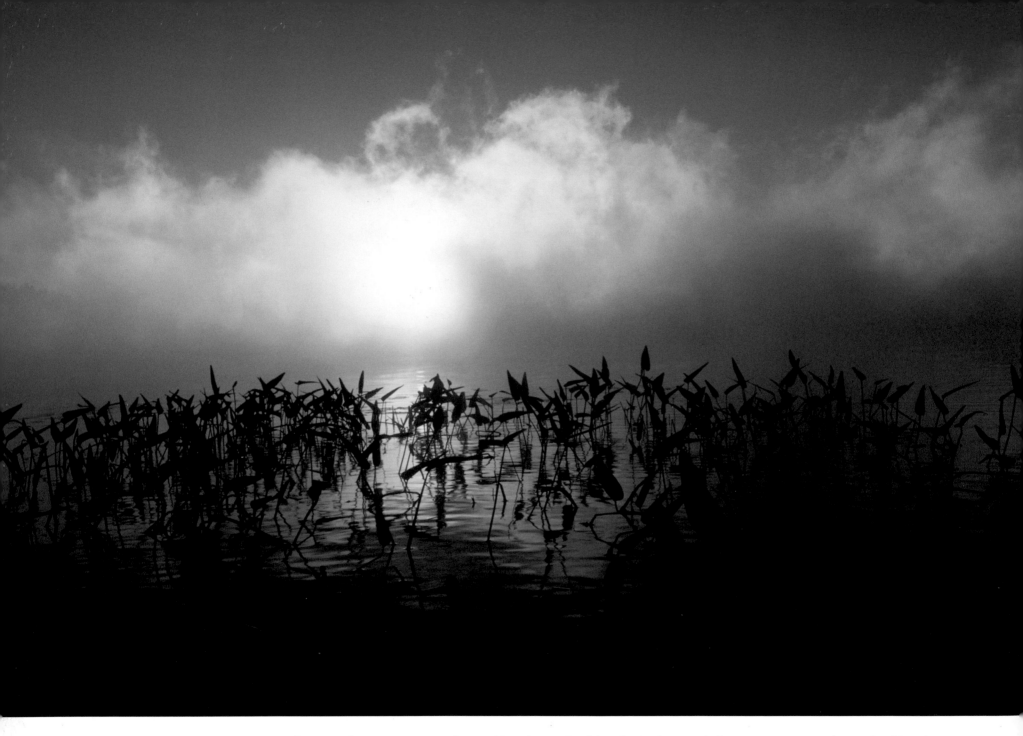

Above: Early morning mist – Osgood Pond, near Paul Smiths. Right: First light – Mountain Pond, near Paul Smiths.
Mist and early morning light create mood and mystery on lakes and ponds that can appear mundane later in the day.

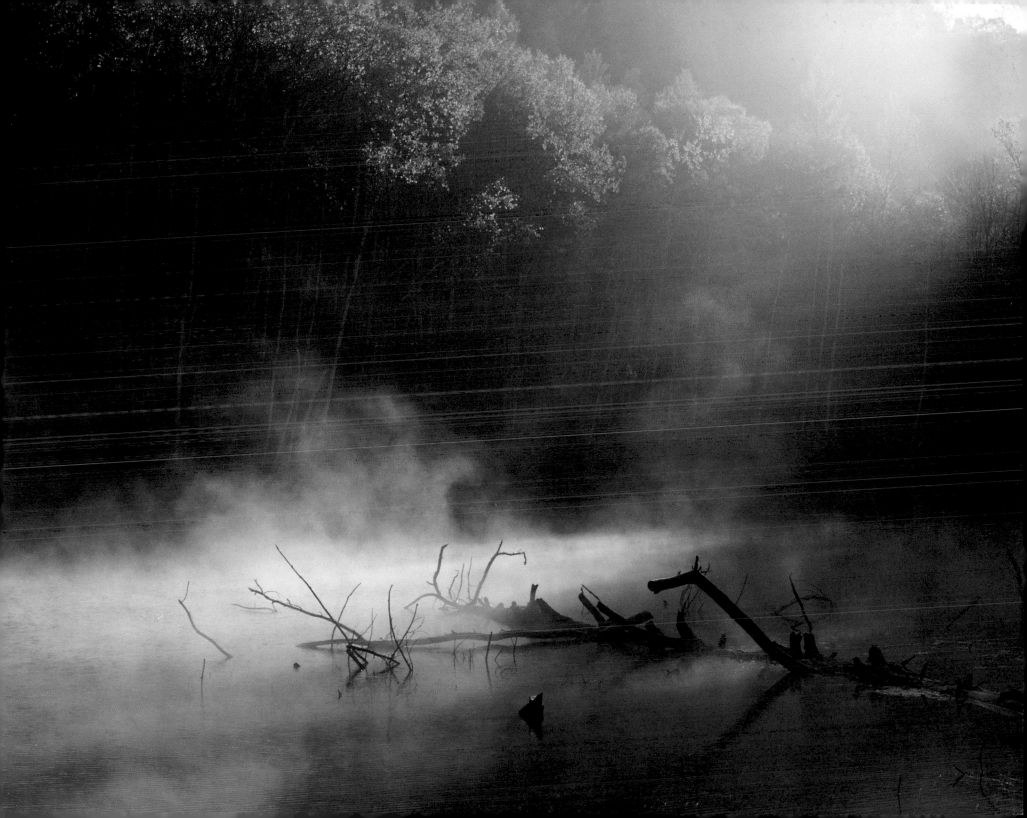

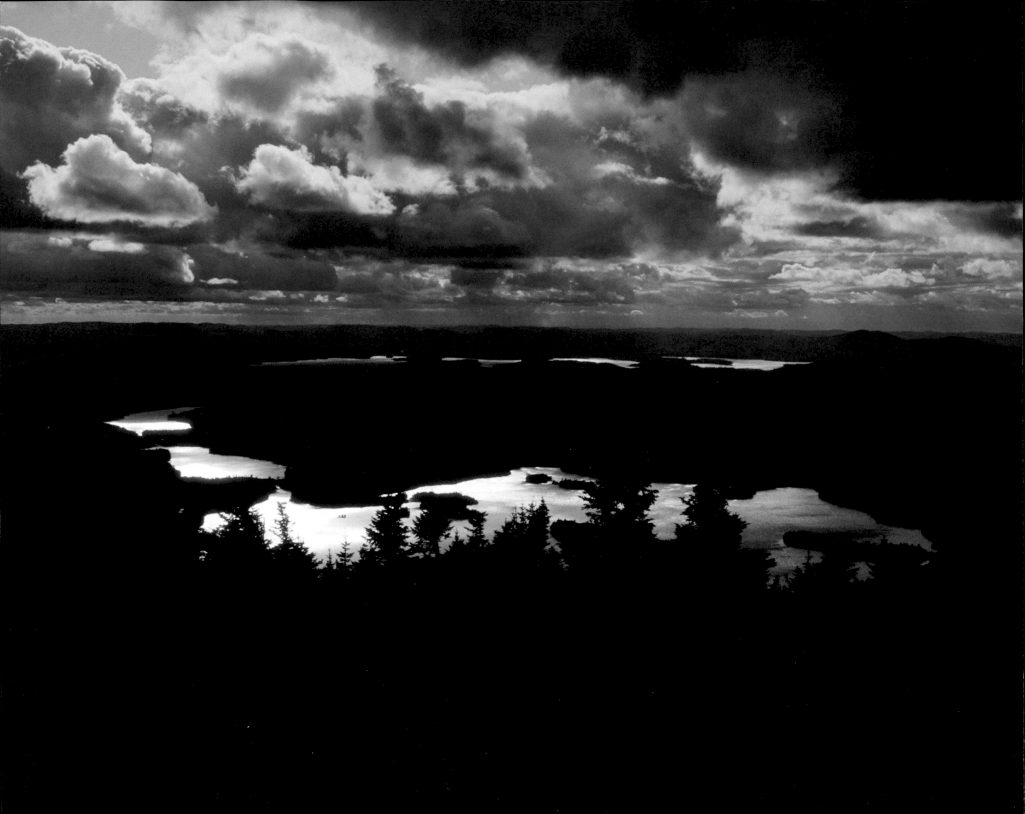

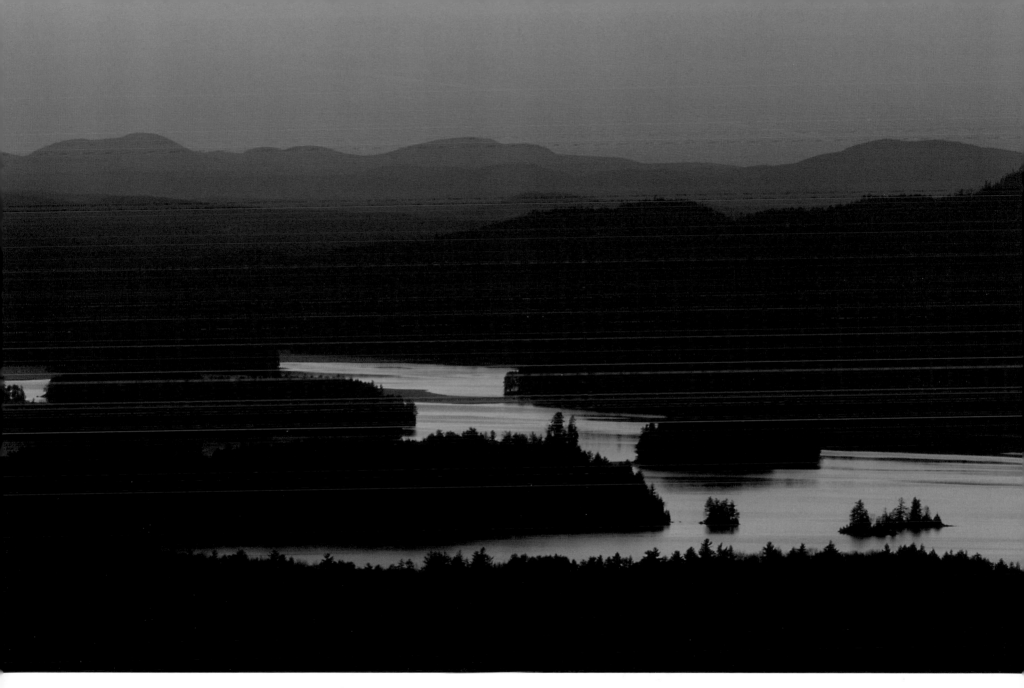

Above: A red ambience fills the landscape surrounding Lower Saranac Lake at dusk – view from Baker Mountain.

Facing Page: Midday sunbeams fall on Blue Mountain Lake, Eagle Lake, Utowana Lake and, in the distance, Raquette lake – view from Blue Mountain, near Blue Mountain Village.

The crests of mountains often provide a panoramic view of mountains, lakes and forests across a horizon.

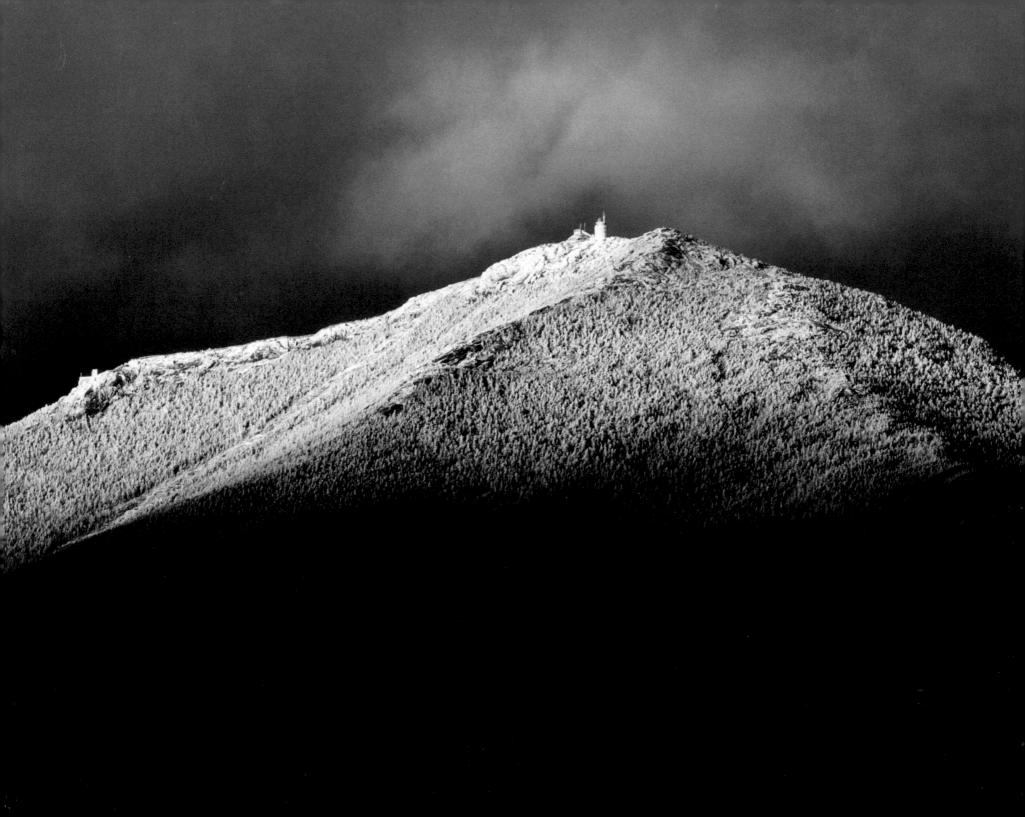

Mountains

Light in the mountains takes on a special quality that is rare in low country. Perhaps this is because mountains are a vertical form on a landscape that is mostly horizontal; or because mountains catch the first and last light of the day. Or perhaps it is because mountains share their space with clouds and rainbows.

Mountains look strong and permanent on the Adirondack landscape, but their environment is in constant change. Imagine clouds exploding in slow motion over a distant range and darkening to thunderheads. Rain starts to fall near the summits and drifts to a valley below. The mountains vanish in the storm, only to be rescued minutes later by sunlight and lifting clouds.

Adirondack mountains like St. Regis, Blue, Snowy, Algonquin and Whiteface are the major focal points of their regions. Whiteface is my favorite mountain, impressing me with its ability to appear and disappear in countless views from lakes, trails and roads. With its face of snow, Whiteface is visible from my front porch, allowing me to observe many of its moods and personalities. Seeing this mountain all the time doesn't mean that I have caught all its moments. It is a mountain of unlimited splendor.

Evening sun on Whiteface Mountain, near Lake Placid.
A moving cloud and a shaft of light from the setting sun stay for only a moment
over Whiteface Mountain, and then the light fades and the cloud is gone.

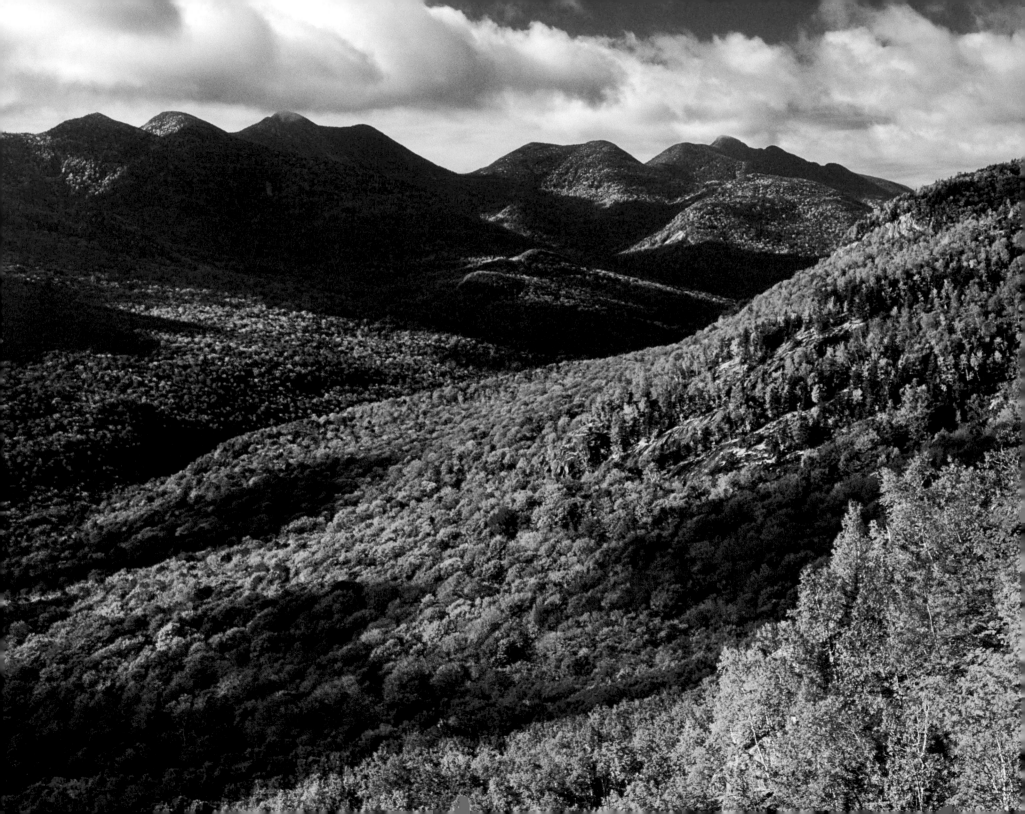

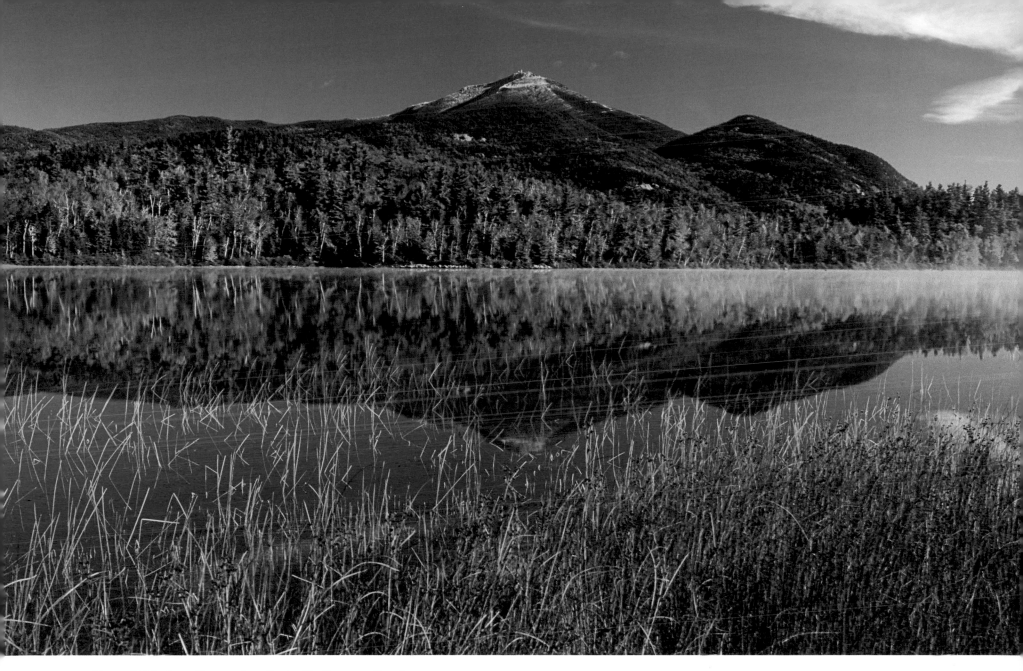

Above: Whiteface Mountain reflected in Connery Pond.
Is it possible that Whiteface has a twin in the depths of Connery Pond?
Facing Page: The Great Range as seen from the First Brother Mountain, near Keene Valley.
I waited impatiently as the morning sun broke over Giant Mountain behind me. Seconds later, the landscape
in front of me was transformed into light, shadows and brilliant color.

21

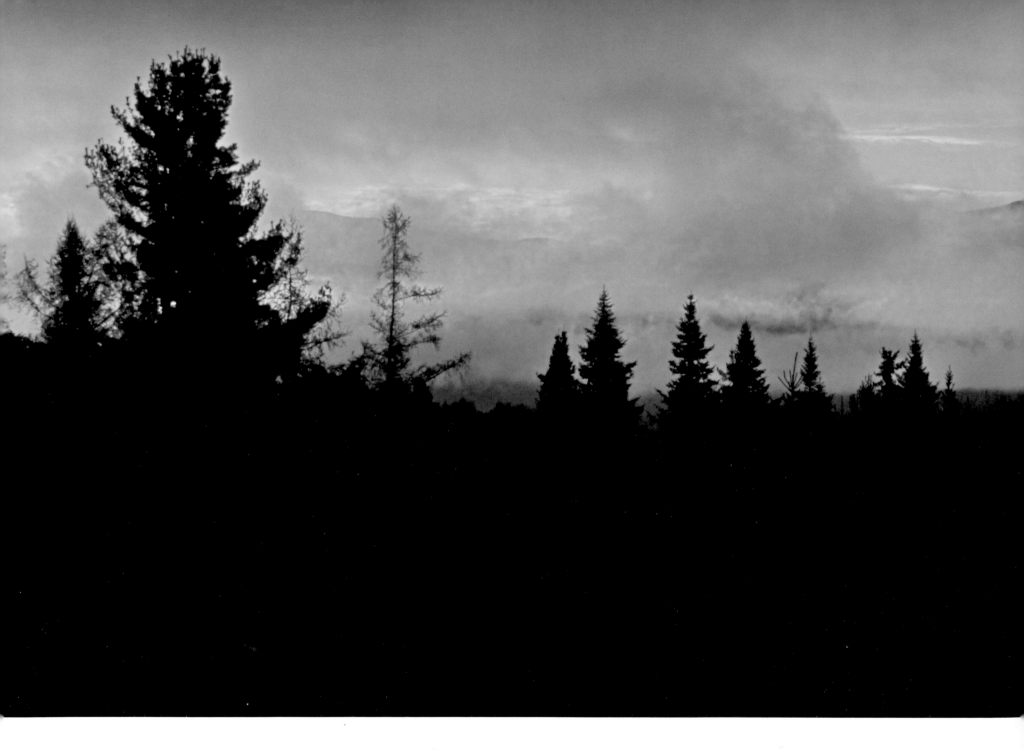

Whiteface emerges from mist and clouds at dawn, near Vermontville.

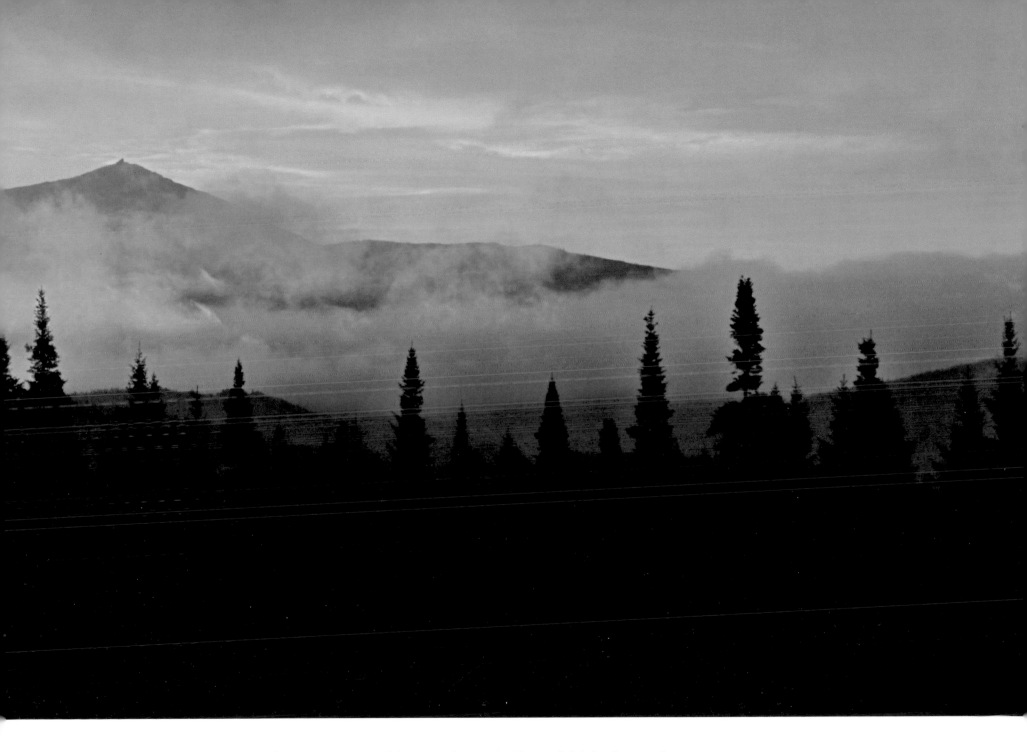

"Nature does nothing merely for beauty, beauty follows as the inevitable result." John Burroughs

Mountain silhouettes in Cascade Lake, near Keene.

The hush of dawn carries its own message – peace!

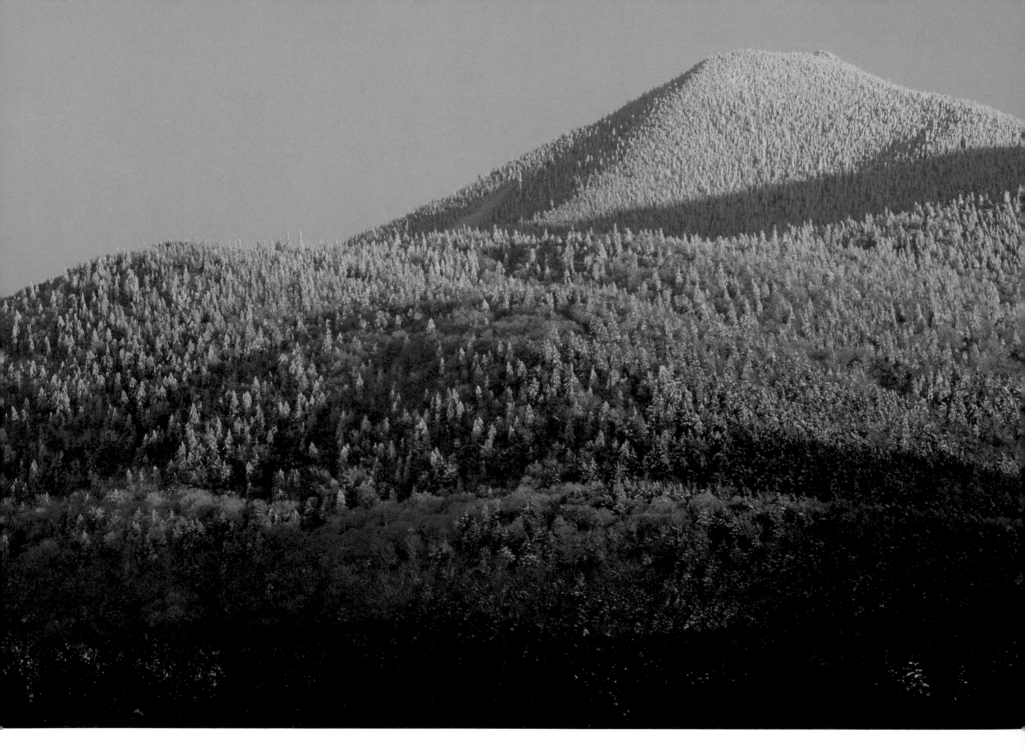

Above: Warm evening light on snow covered trees and Moose Mountain, near Saranac Lake.

Facing Page: Mountain mosaics, near Keene.

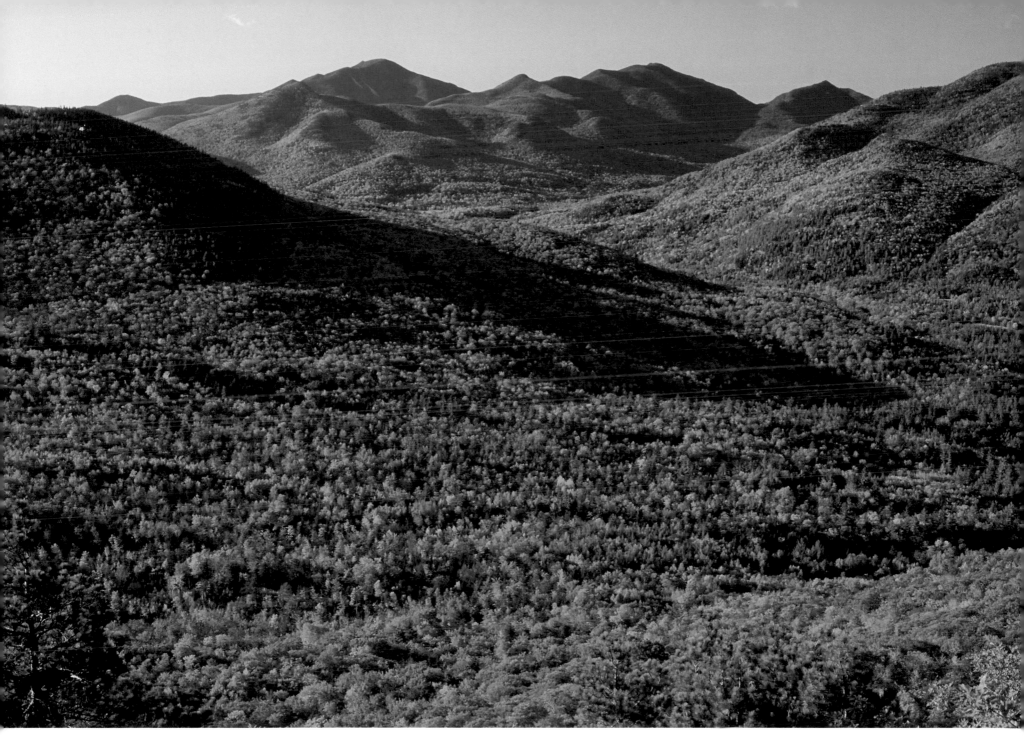

A mantle of trees covers most Adirondack mountains, and changes with the seasons and the time of day.

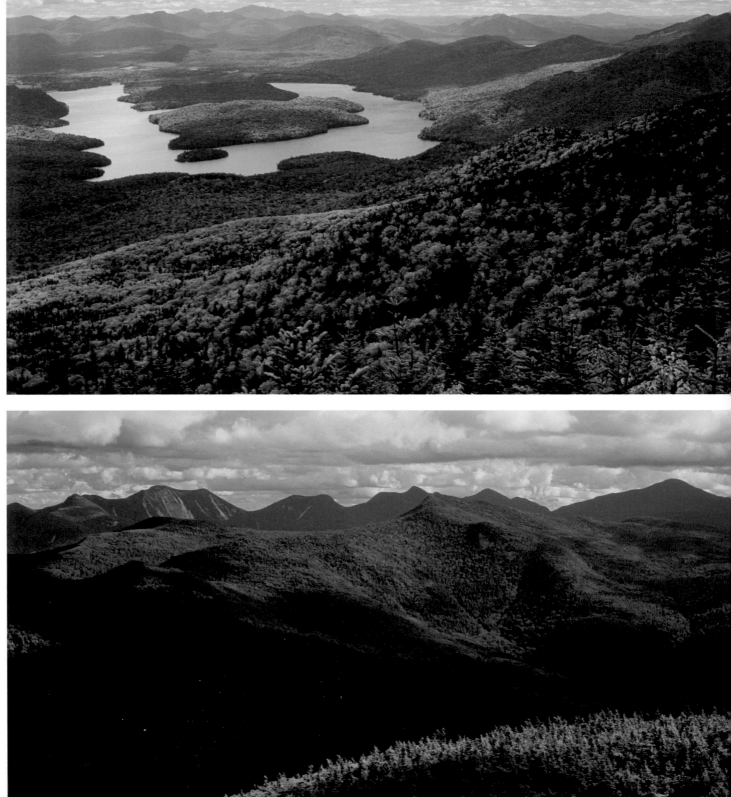

"Thousands of tired nerve-shaken, over-civilized people are beginning to find out that going to the mountains is going home..." John Muir

Top: Lake Placid as seen from Whiteface Mountain, near the village of Lake Placid.
Bottom: view of the High Peaks as seen from Cascade Mountain, near Keene.

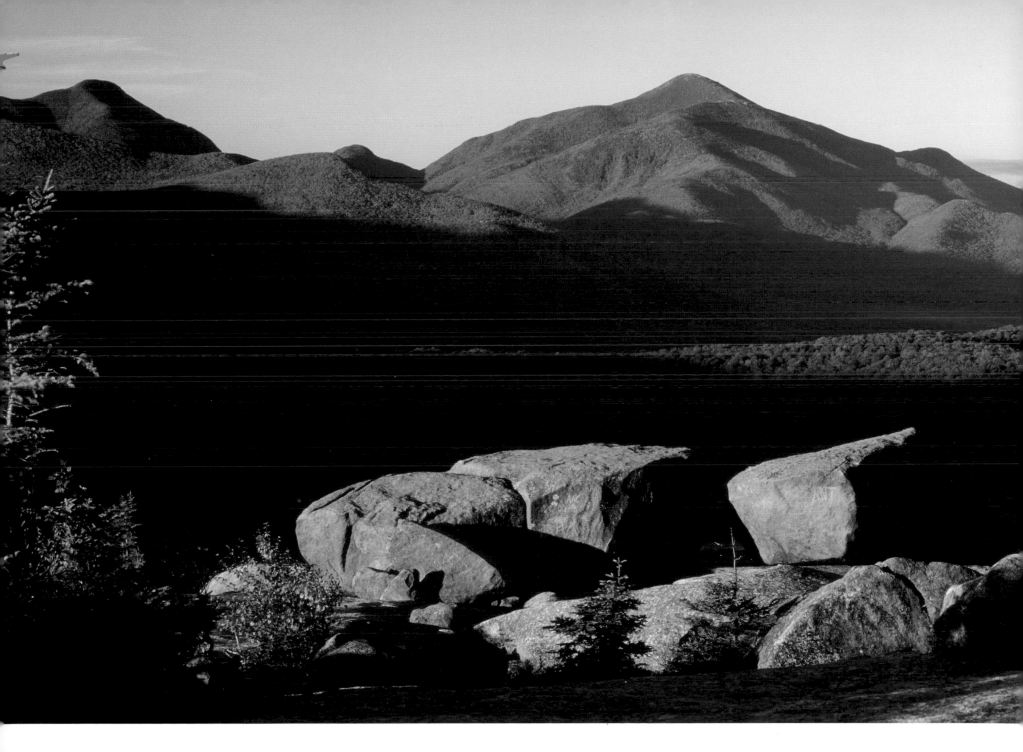

Glacier-deposited rocks on Pitchoff Mountain with Algonquin Mountain in the distance on the right, near Keene.

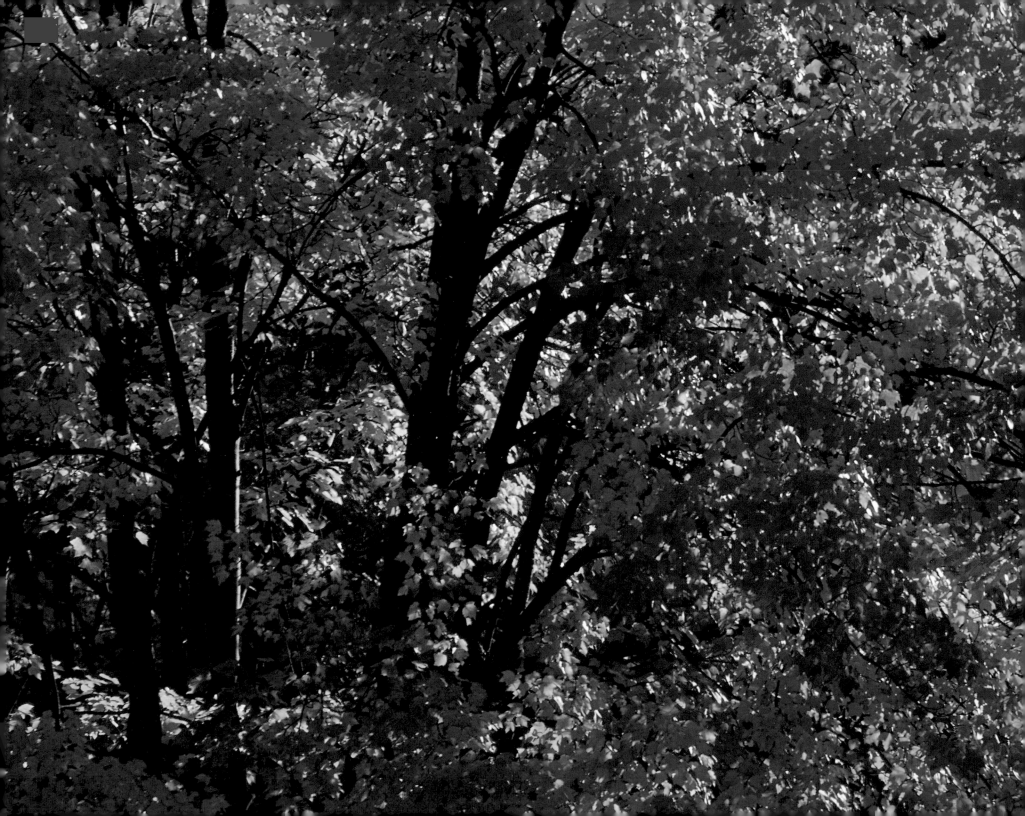

Trees

It seems that people pay more attention to mountains, lakes and rivers than they do to trees and forests. Perhaps this is because forests are everywhere in the Adirondacks. One doesn't have to make a special trip to be among trees.

Henry David Thoreau thought differently. He wrote, " I frequently tramped eight or ten miles through the deepest snow to keep an appointment with a beech tree, or a yellow birch, or an old acquaintance among the pines ..."

All trees have their moments, but I am partial to white birch framed by a blue sky, heavy frost on balsam fir and spruce needles, and the first green of trembling aspen. The blossoms of shad and fire cherry are a welcome sight in spring, and I like a wet snow on a mix of conifers and hardwoods. But I wait most impatiently for autumn because nothing equals the blaze of sugar maple, the yellowing of aspen, or the smoky gold of tamarack.

Moments with trees are a time for mind and spirit to heed the voice that comes from the forest.

Facing Page: Close-set red maple trees offer an extravagant display of autumn color, near Paul Smiths.
"The gold of nature does not look like gold at first glance. It must be smelted and refined in the minds of the observer." John Burroughs

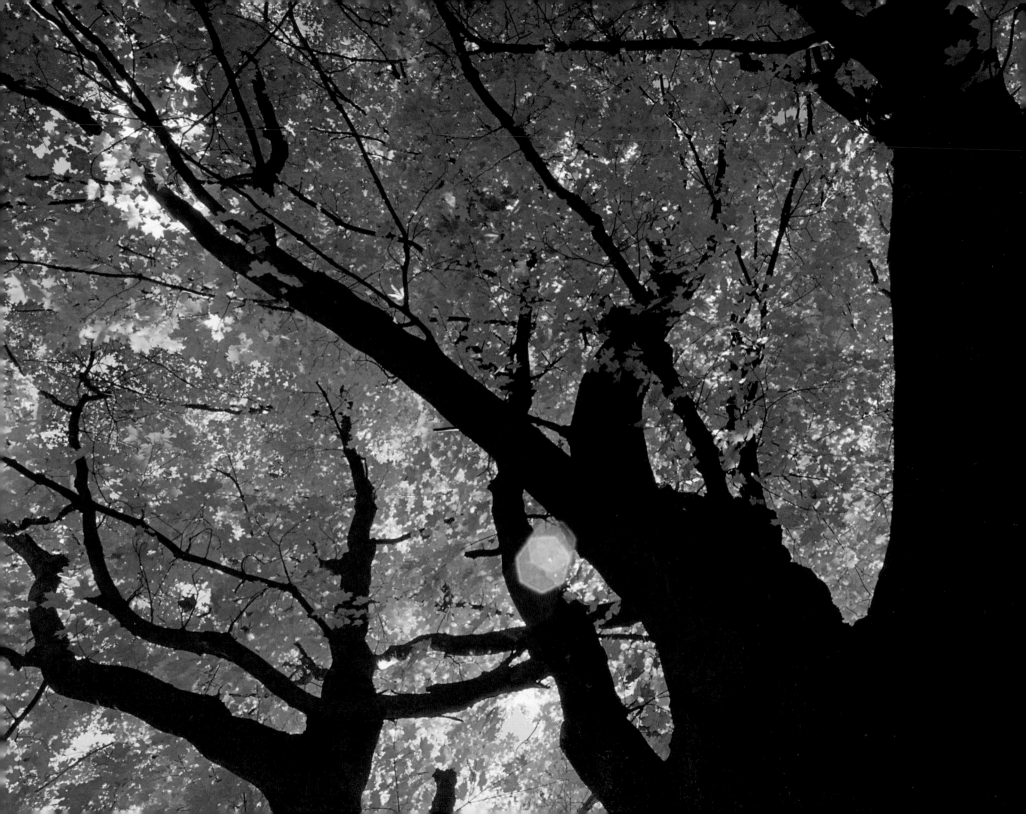

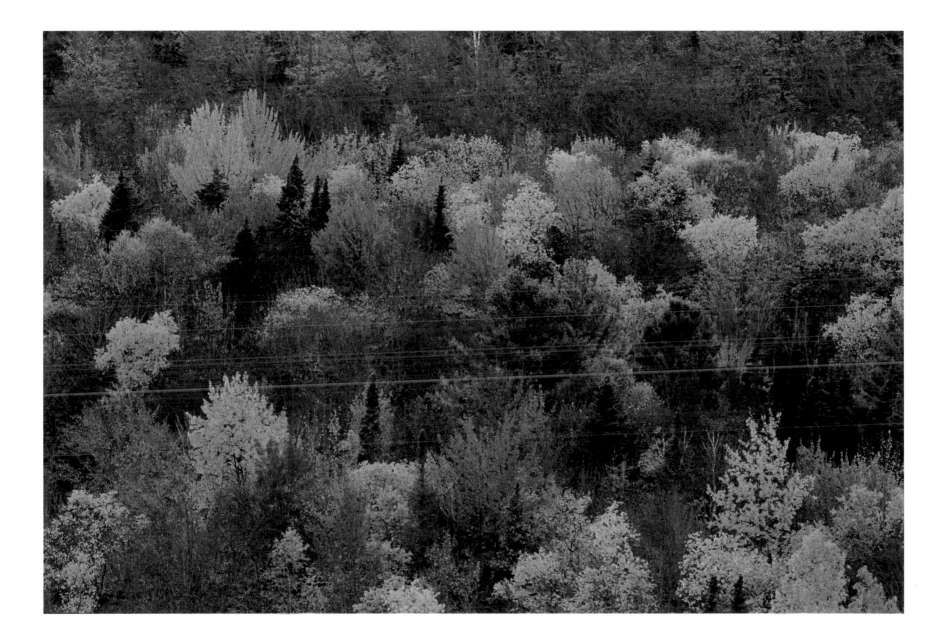

Above: Fading evening light gives a mix of evergreens and hardwoods a warm radiance, near Lake Placid.
Facing Page: Large twisting branches of an old sugar maple support a massive canopy of leaves, near Keene.

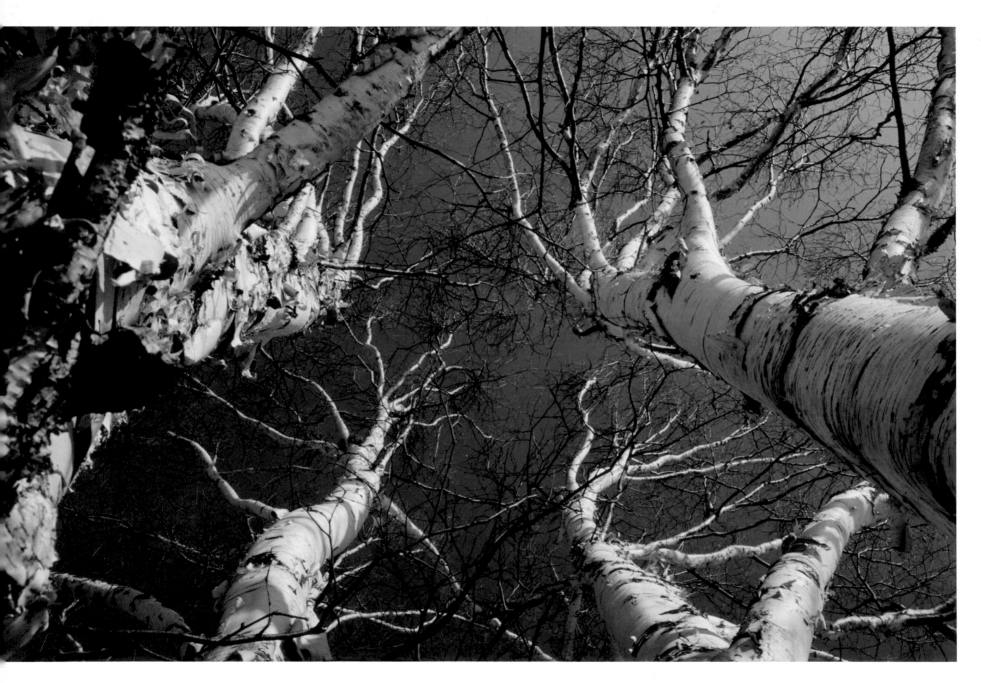

Above: White birch trees reach for a blue sky, near Keene Valley.
Facing Page: Gray birch and red maple on the shore of Chapel Pond, near Keene Valley.
White and gray birches have the distinction of being the only white trees in the Adirondacks.

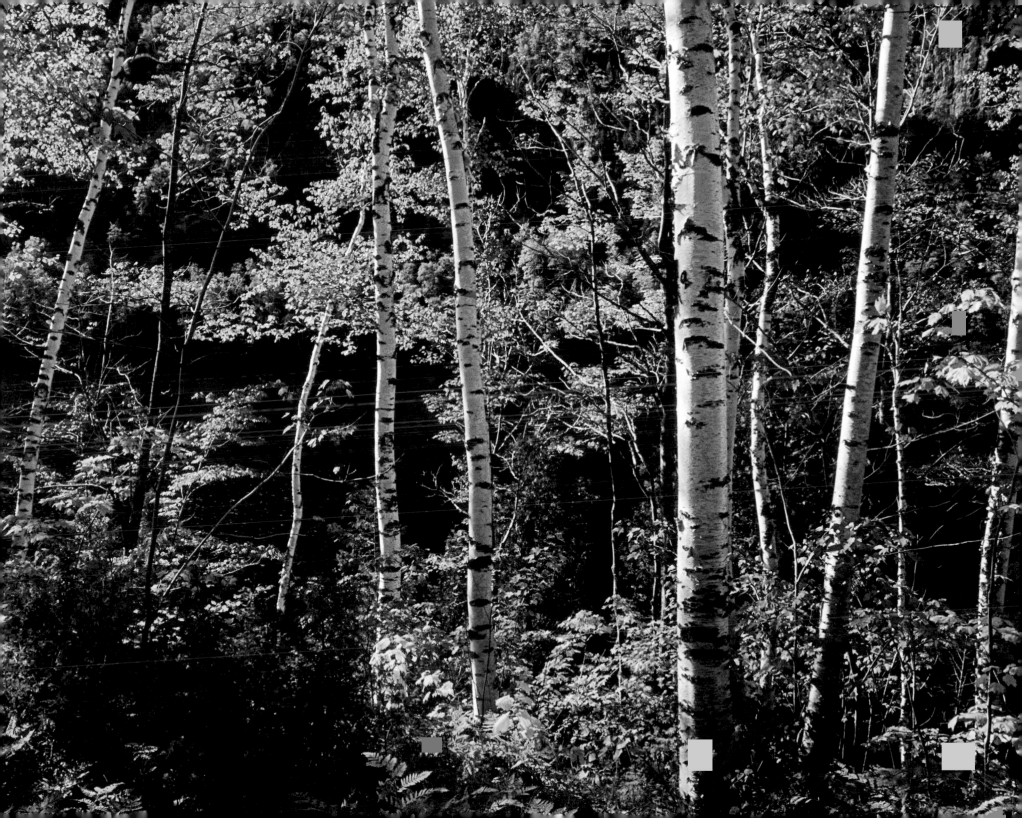

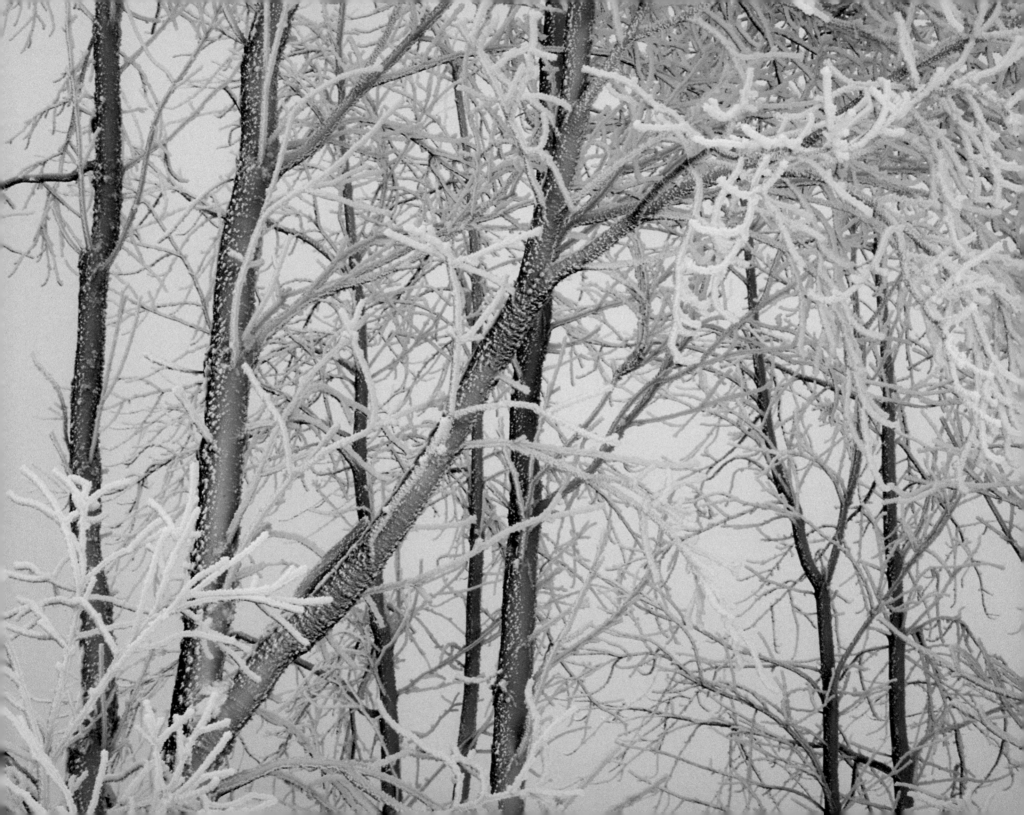

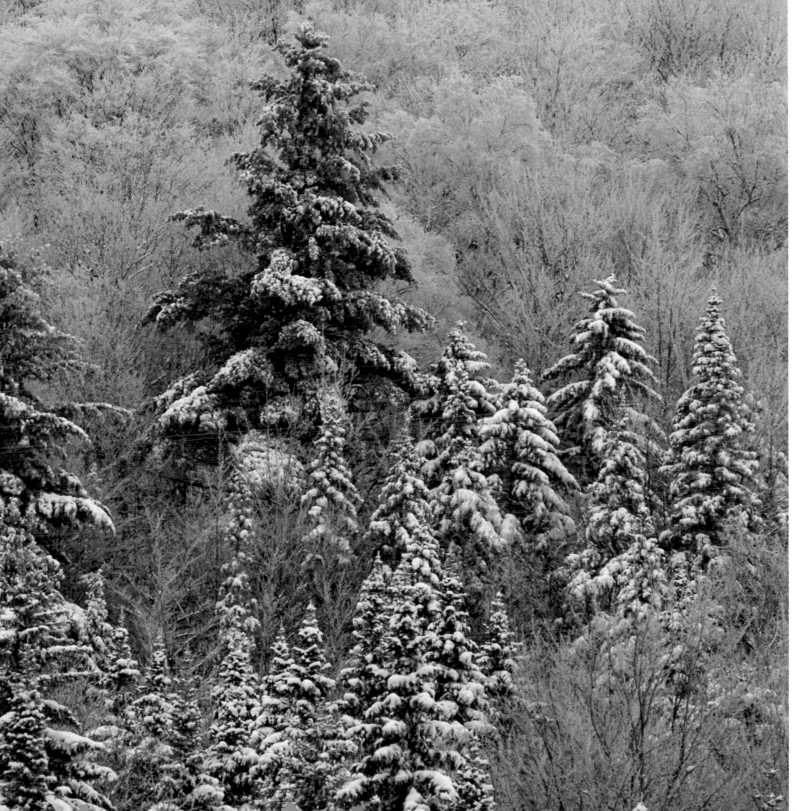

The magic of change is always present in nature.

Left: Fresh wet snow on evergreens and hardwoods on Church Mountain, near Vermontville. Facing Page: Frosted red maple stems, near Vermontville.

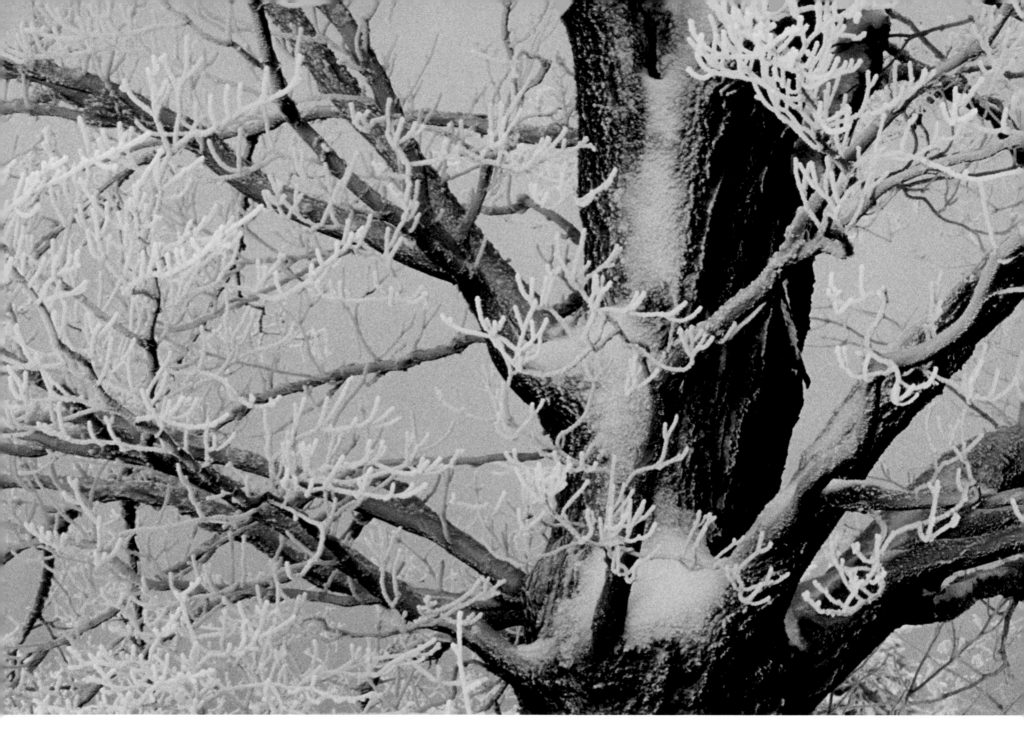

Frosted sugar maple, near Vermontville.

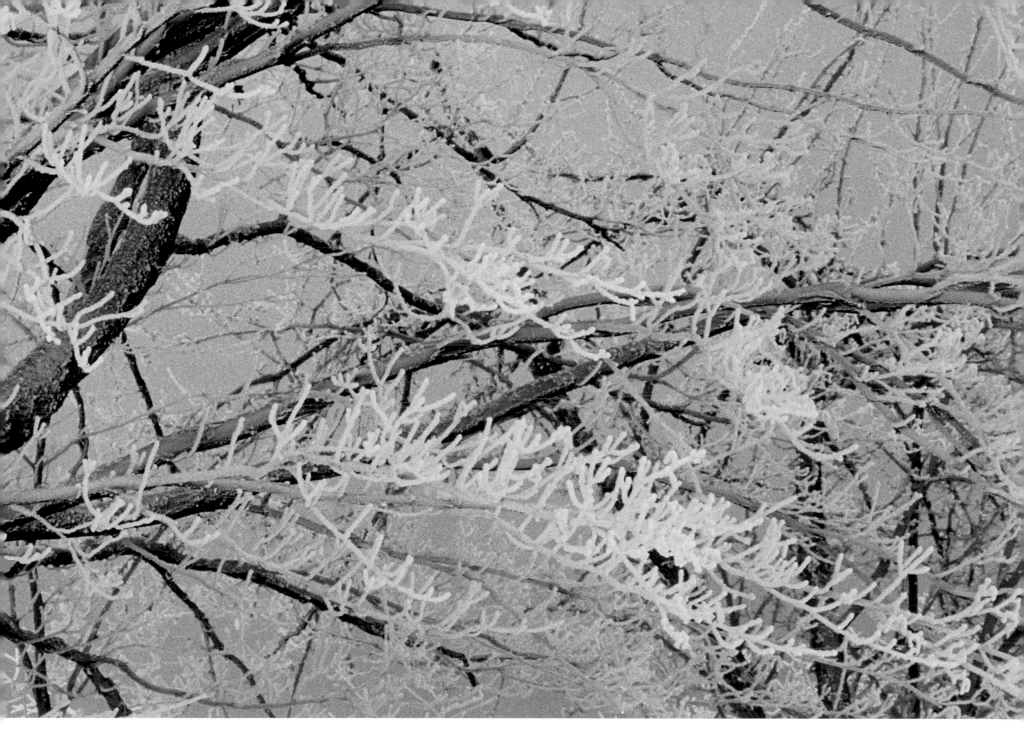

A sugar maple is transformed by frost.

White bark and red leaves
complement each other.

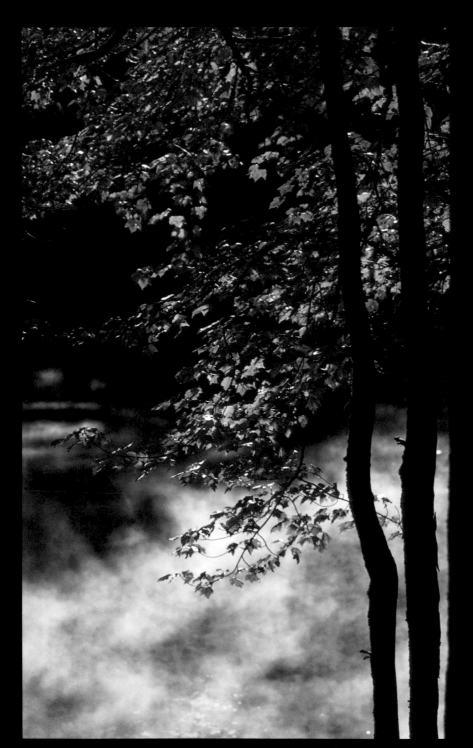

*Right: Red maple trees catch the
morning light, near Paul Smiths.
Facing Page: Gray birch stems and
red maple leaves, near Keene.*

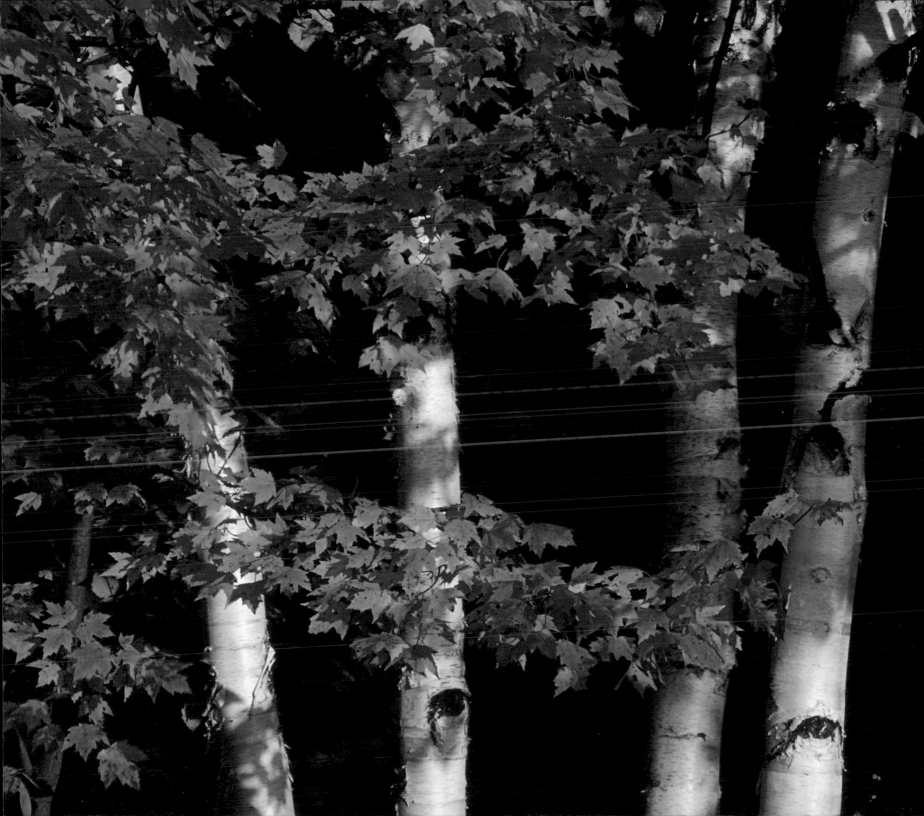

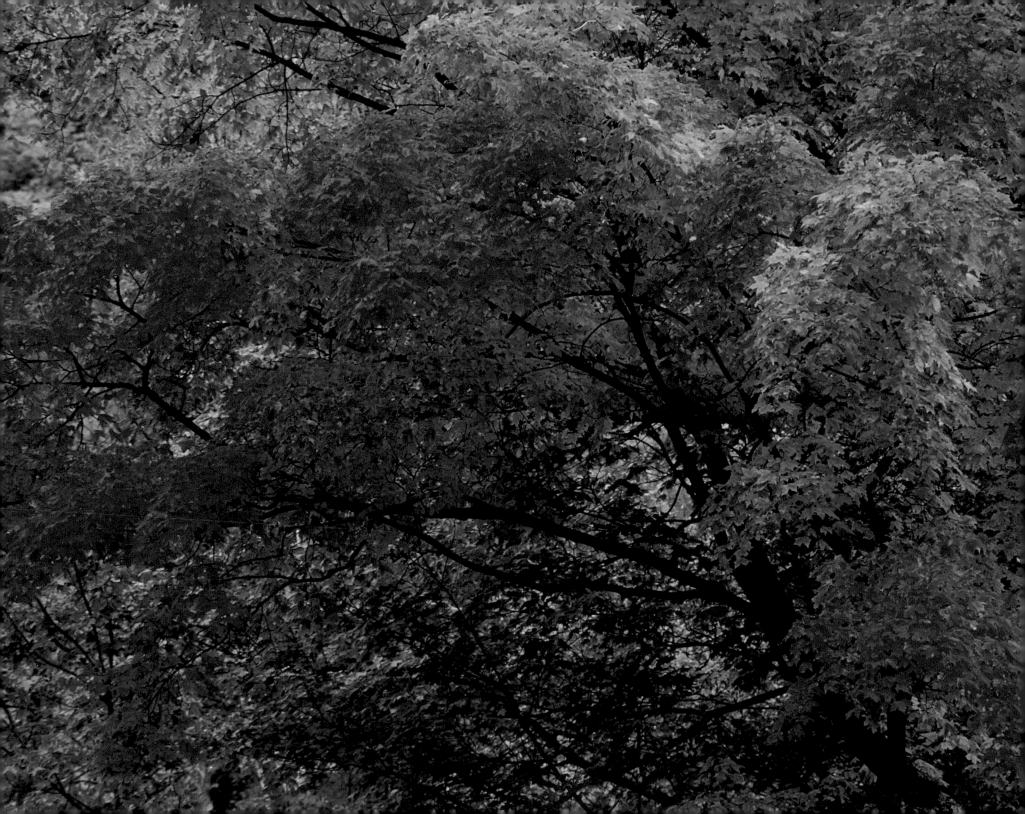

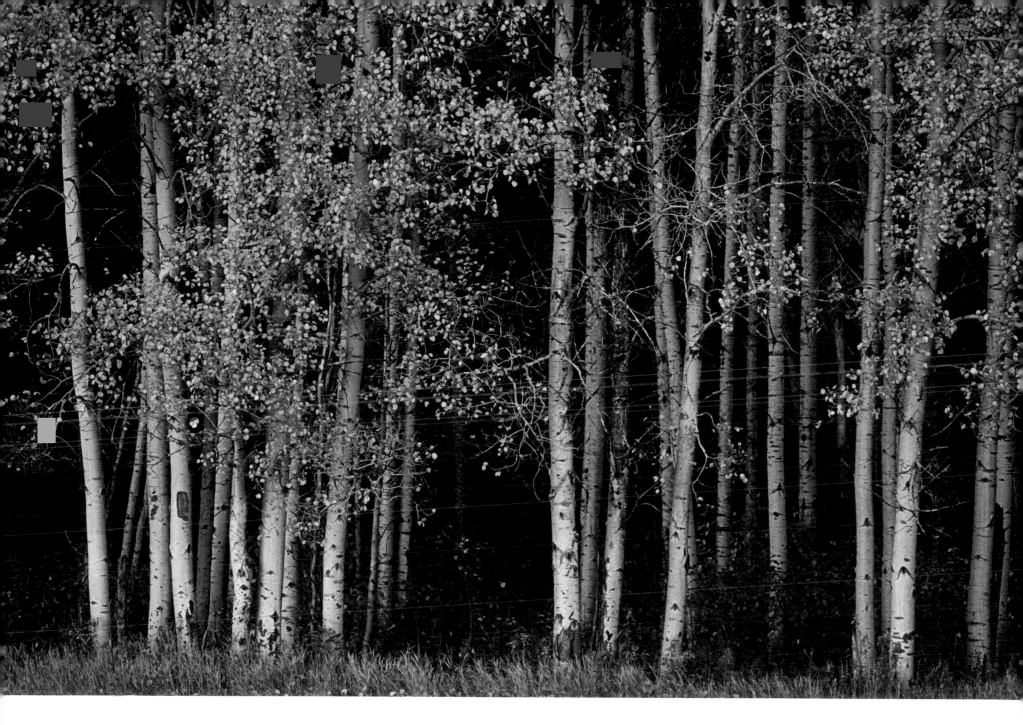

Above: Trembling aspen trees in evening light, near Bloomingdale. Facing Page: A big red maple in all of its glory, near Lake Placid.
The paint of autumn begins on a few leaves, progresses to a crescendo of colors everywhere, and then, only a few colorful stragglers remain.

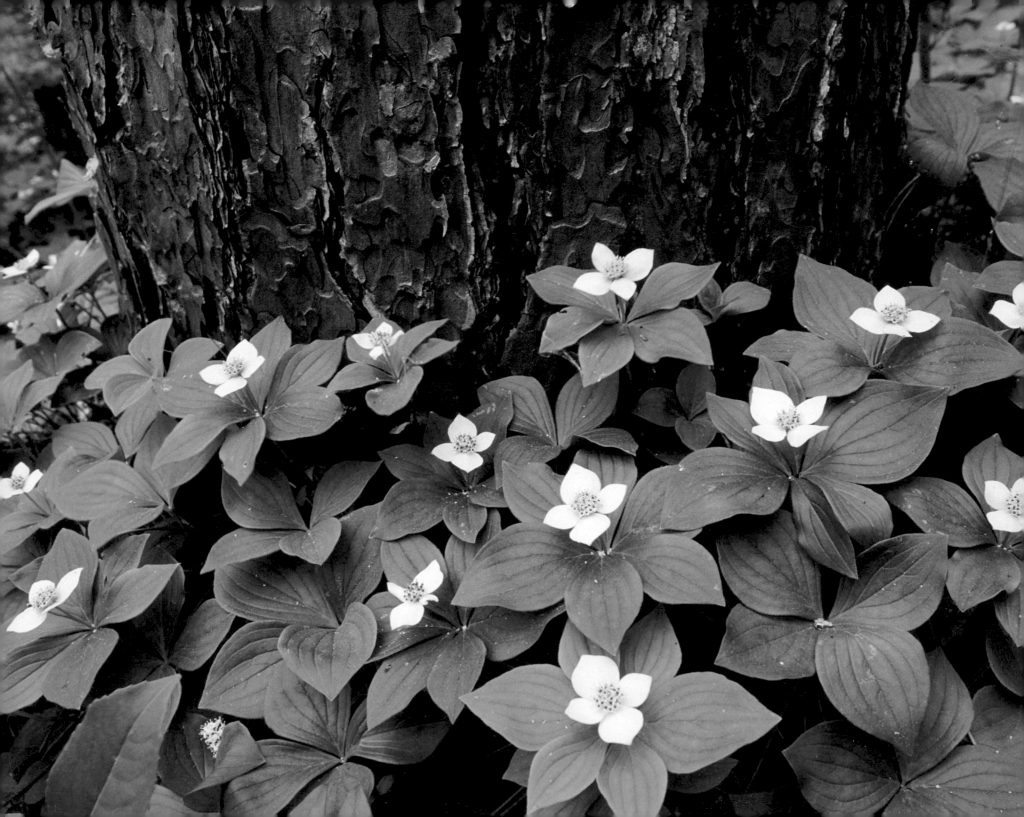

Plants and Wildflowers

The first stage of spring is the thawing of snow and the unveiling of last fall's brown landscape. The second stage begins when the green- and gray-speckled leaves of trout lilies push through the matted leaves on the forest floor. This is the signal that the parade of wildflowers has begun. Yellow blossoms will appear on the trout lilies in a few days, to be followed by purple trillium and spring beauty. Painted trillium, Canada mayflower and star flower will emerge next as the procession of forest flowers follows a sequence that repeats itself every year.

Time is important to woods flowers since many of them struggle to blossom before sunlight is blocked by growing hardwood leaves overhead. More shade-tolerant flowers, such as pink lady's slipper and bunchberry, come out after the canopy closes and the spotlight shifts to meadow flowers.

Field daisies, hawkweed and cow vetch lead the meadow promenade, followed by meadow sweet, fireweed and Queen Anne's lace. The urgency of seeing the first flower of spring has faded by the time meadow flowers arrive. The field flower progression continues throughout summer and even as the first splashes of crimson break out on red maple.

Only nature knows when wildflowers will show or depart on a landscape. Their schedules vary from year to year, along with the schedules of first snows, autumn colors, and ice out on ponds and lakes. Wildflowers are tuned to their own moments. Humans must realize that nature does not conform to the expectations of people.

Mushrooms, ferns, mosses, lichens, alpine plants, aquatic plants, and forest and meadow plants are found in various ecological niches throughout the Adirondacks. They provide diversity and miniature landscapes wherever one goes in this beautiful park. Take a minute to observe their leaves, shapes and characteristics. You'll recognize them when you see them again.

Facing Page: Bunchberry blossoms surround the trunk of a red pine tree, near Paul Smiths.

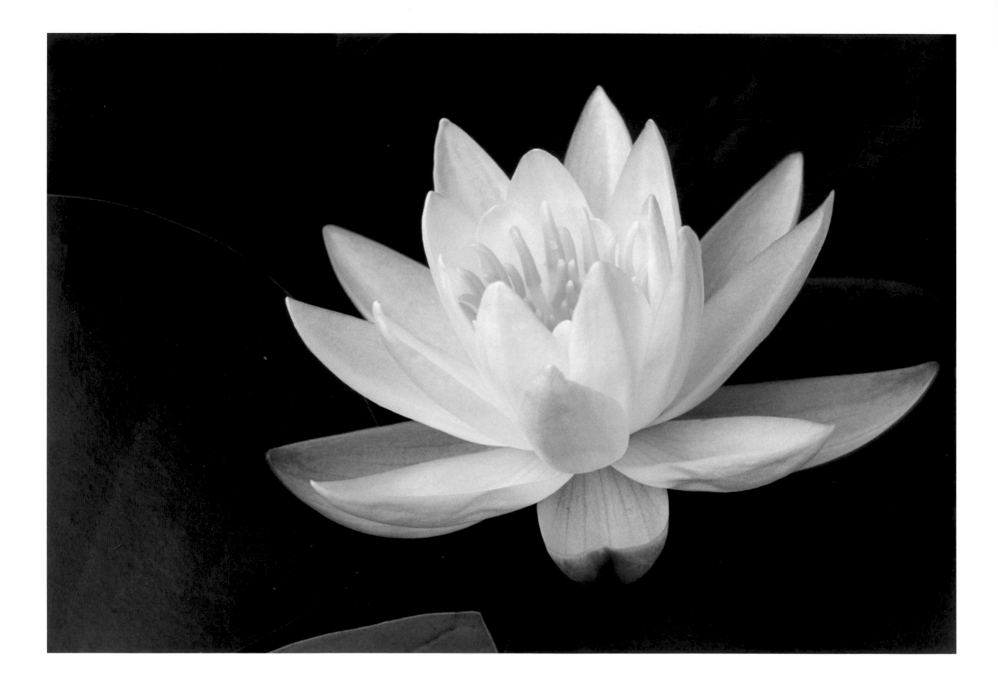

Above: Fragrant water lily.
Facing Page: Yellow pond lily.

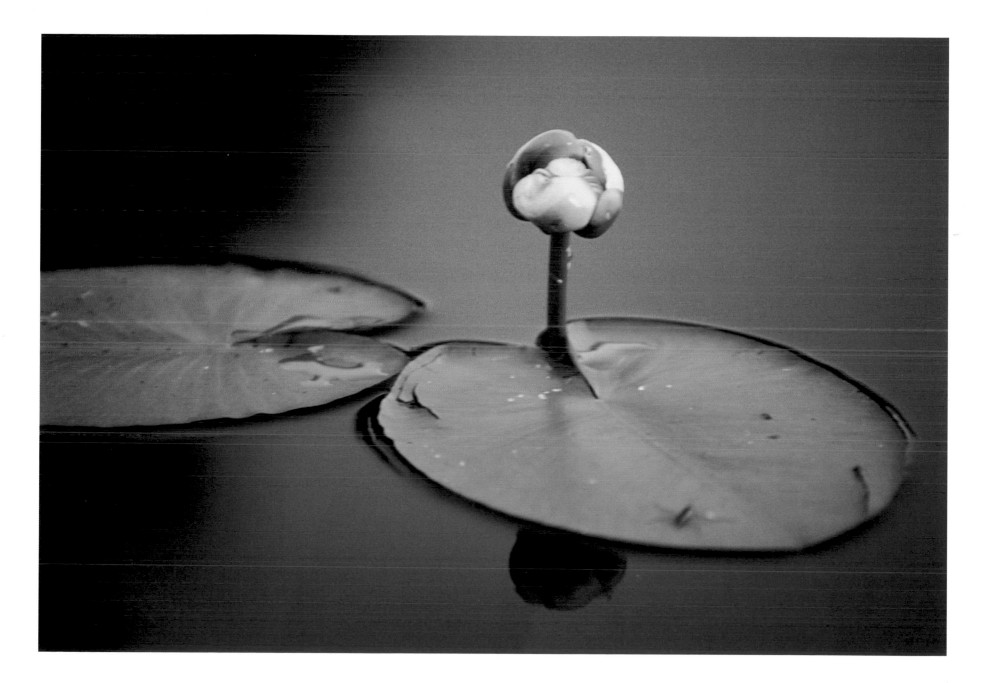

Lily pads can provide a landing field for dragonflies and damselflies, and perhaps an occasional frog.

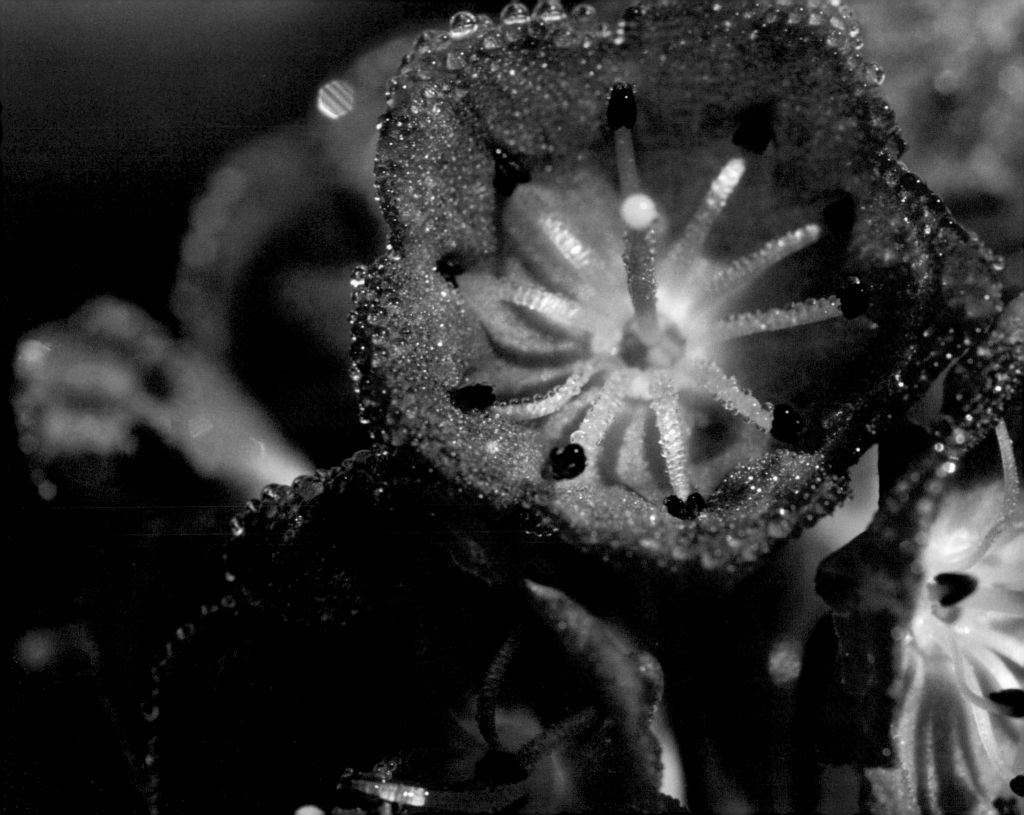

Dewdrops on bog laurel blossoms.
Bog laurel, leatherleaf, bog
rosemary, cottongrass, sheep
laurel, Labrador tea and sphagnum
mosses only grow in bogs because
they need an acidic environment.

49

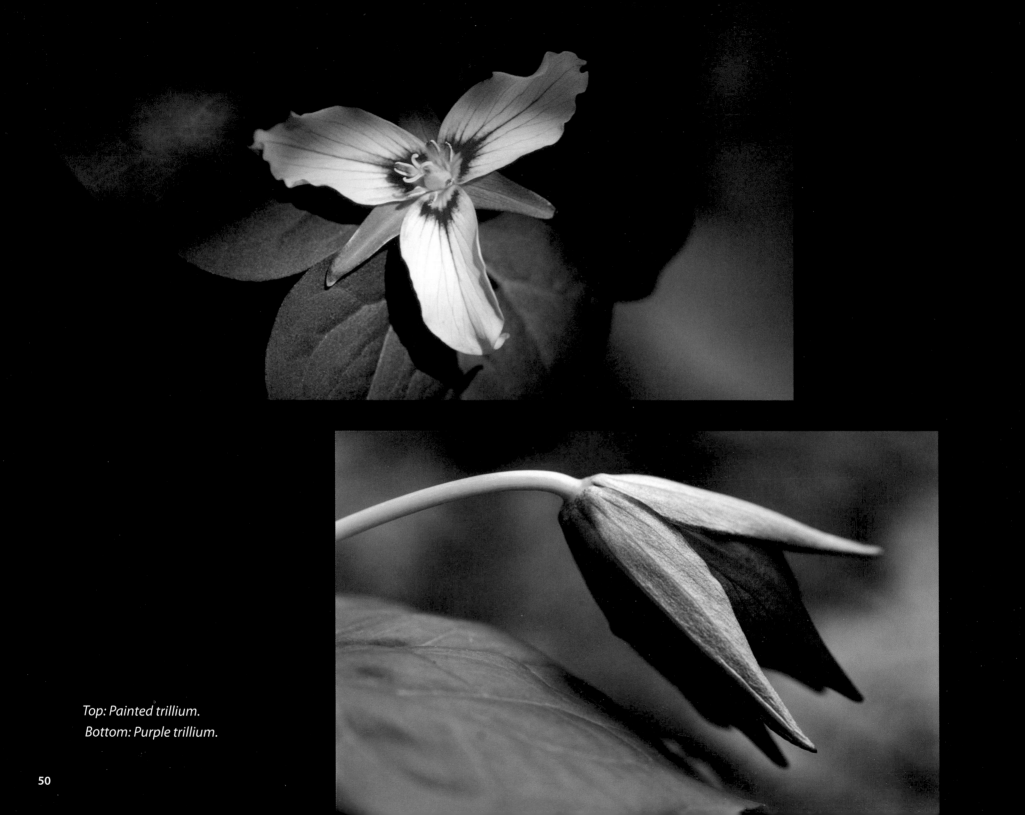

Top: Painted trillium.
Bottom: Purple trillium.

50

"In June as many as a dozen species may burst their buds on a single day. No man can heed all of these anniversaries; no man can ignore all of them." Aldo Leopold

Pink lady slipper.

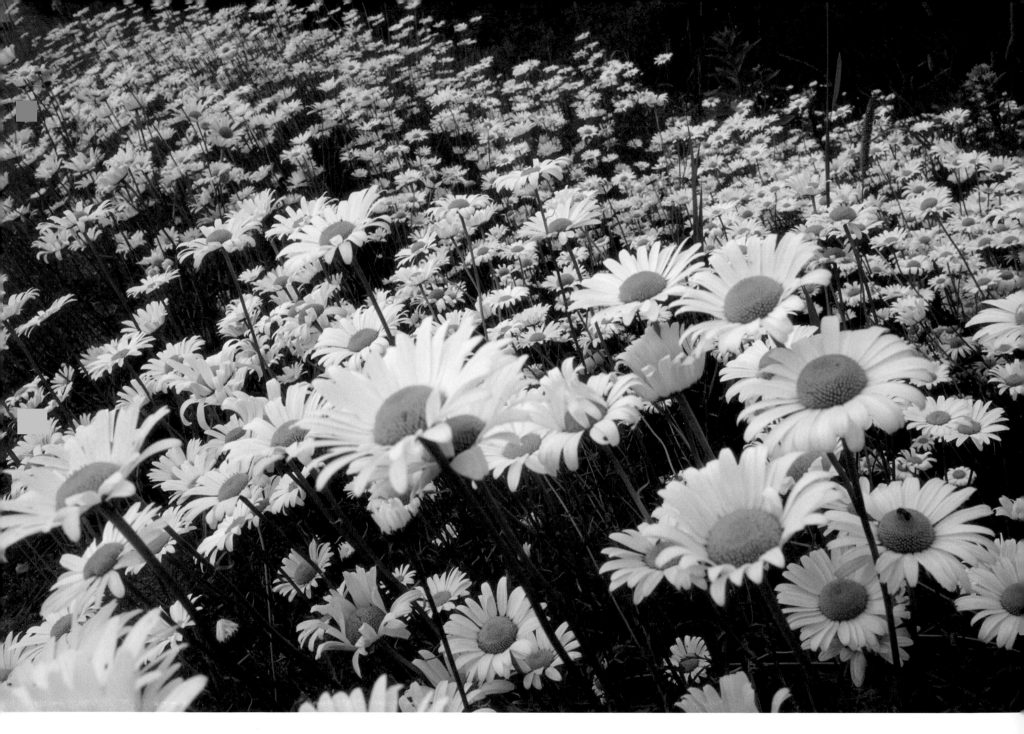

Field of daisies blowing in the wind.

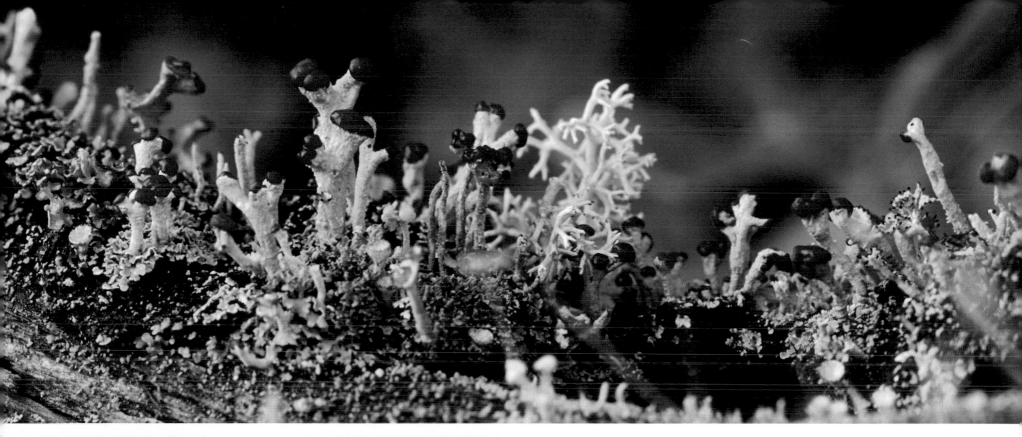

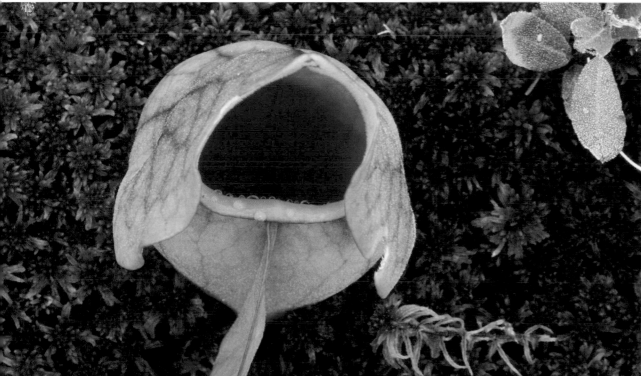

Top: British soldier lichen growing on top of a log.
Lichens are part alga and part fungus. The fungus provides the plant structure and the alga makes food with its ability to photosynthesize.

Bottom: Looking down the hungry mouth of a carnivorous pitcher plant.
When insects fall into the water at the bottom of the plant, they drown and are digested.

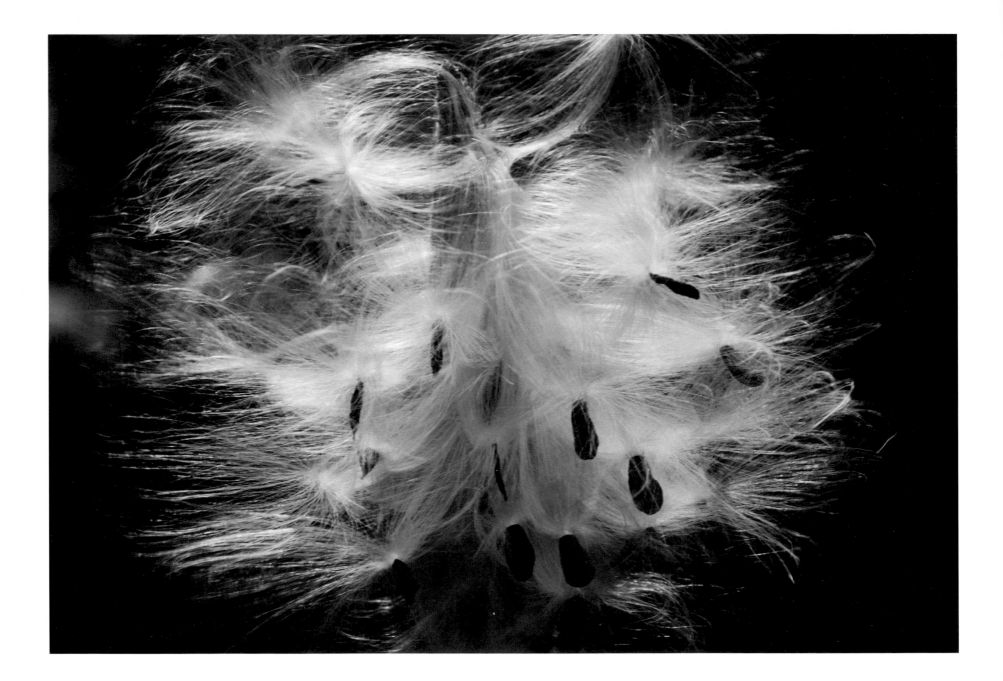

Milkweed seeds.
The silky threads of a milkweed seed catch the wind that transports them to a new location to germinate.

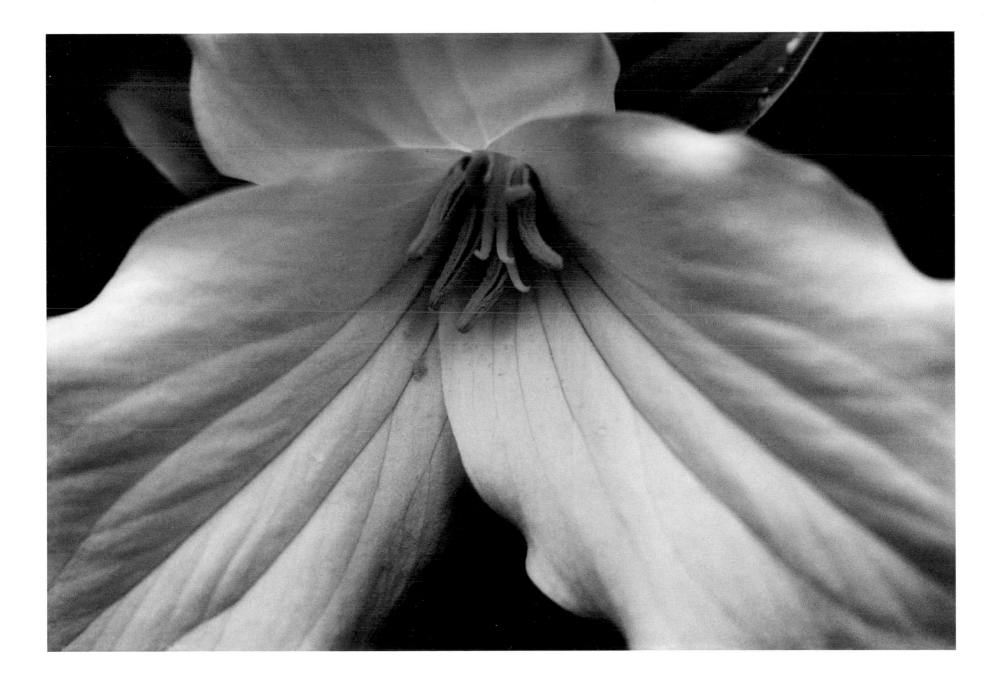

Large flowered trillium.

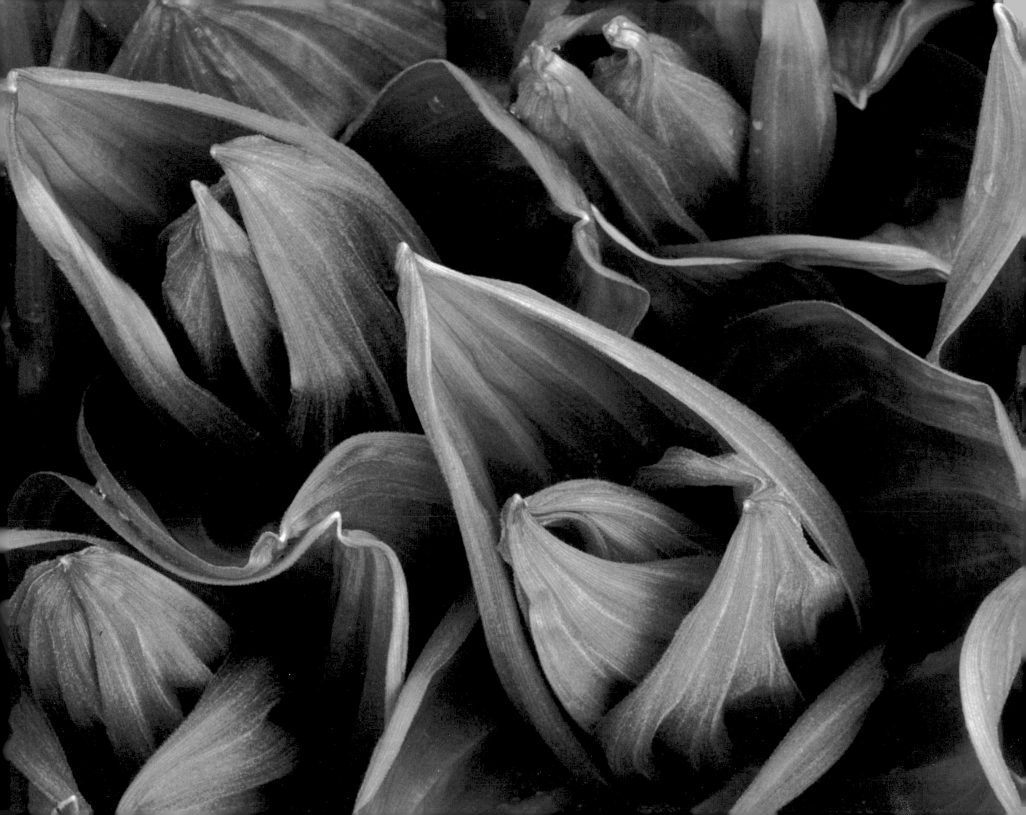

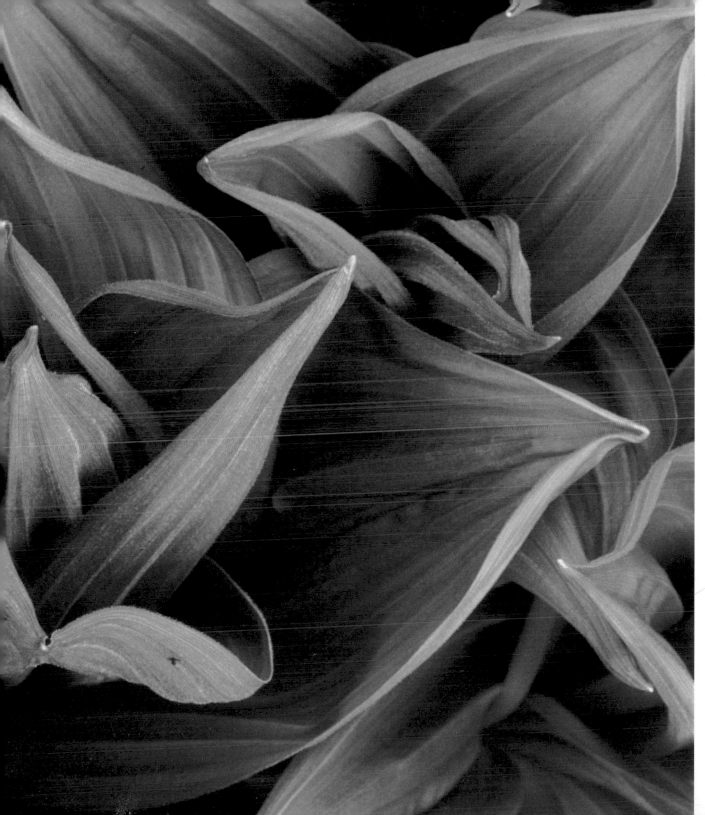

The diverse shapes of nature's leaves are endless.

False hellebore.

Rays of sunlight from behind bring out red maple colors – near Keene.

Autumn Leaves

Silence filled the autumn woods. Sugar maple leaves were breaking away from parent trees and floating through tranquil air. All around me leaves were transporting autumn's yellow, orange and red to the forest floor.

I sat on a log and tried to remain still. I didn't want to make a sound to disturb the serenity and peacefulness. The hush was so intense that I could hear the soft sounds of leaves bumping into branches and making gentle landings on cushions of fallen leaves.

Autumn leaves travel only a short distance, but along the way a season goes with them. Spruce, balsam and pine catch these colorful leaves and hold them momentarily in their needles for an overnight frost.

Come morning, some leaves will have a rim of frost on their outer edges, while others will wear a glitter over their entire surface. Sunlight will sparkle from tiny daggers of ice and give each leaf a blush of brilliance. Searching for autumn leaves on a frosty morning is a fussy business since there is no shortage of moments.

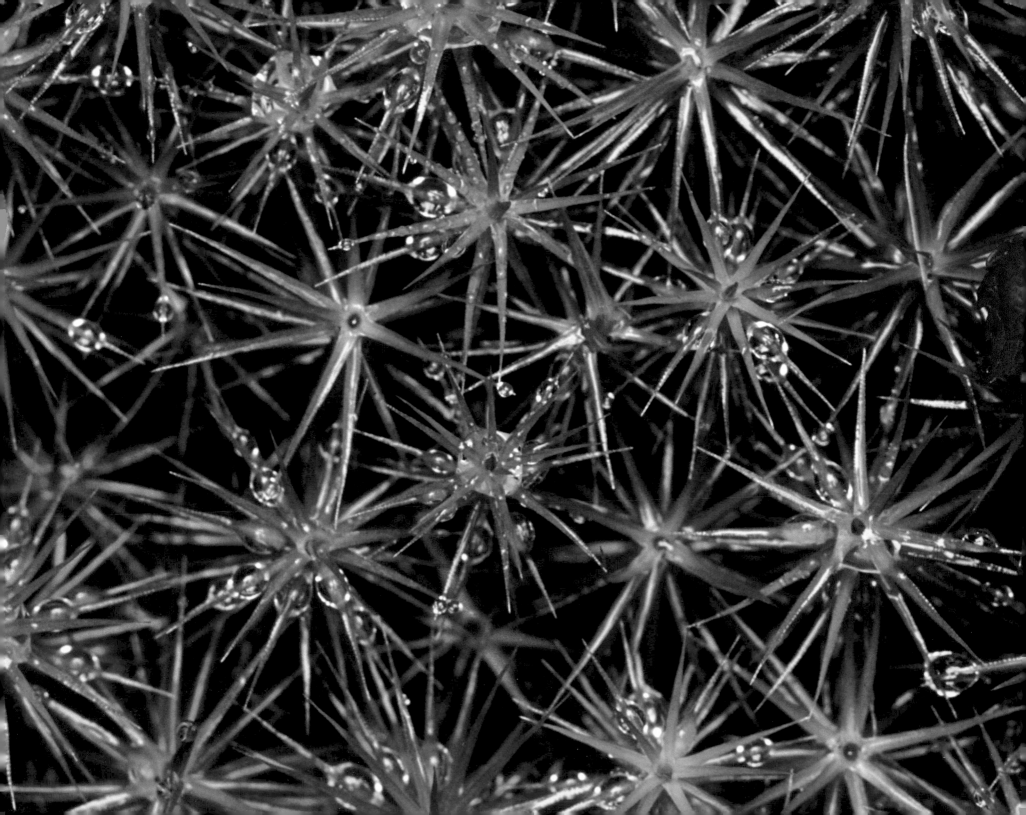

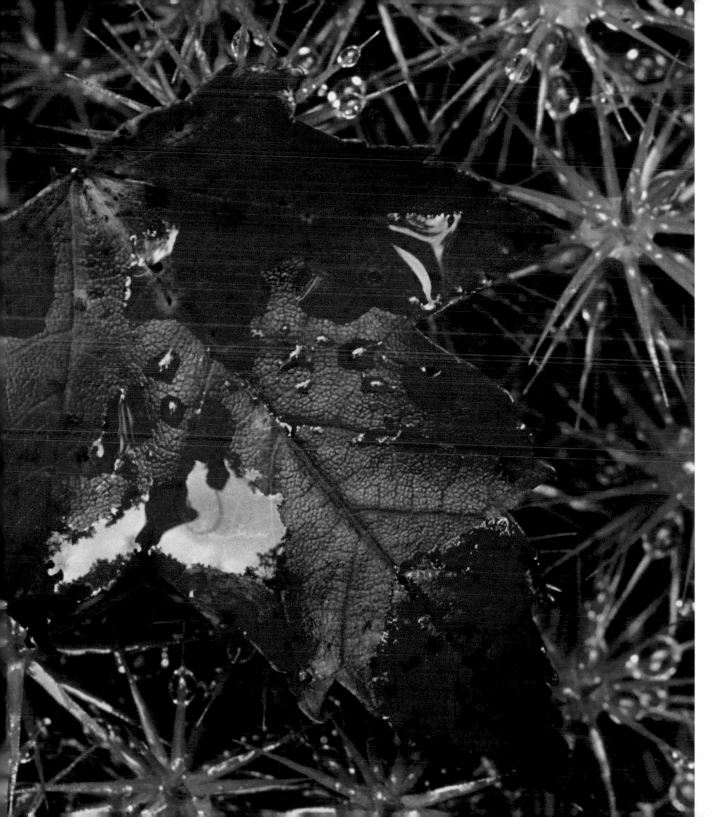

Nature arranges everything in a pleasing way.

Morning dew on red maple leaf and haircap moss.

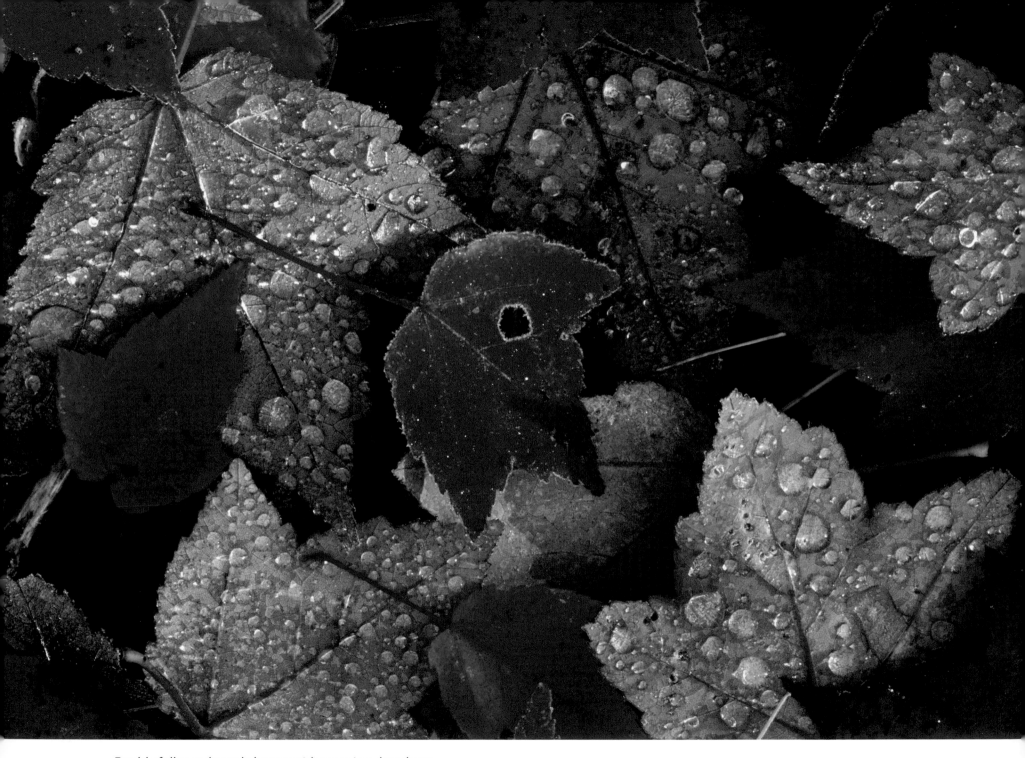

Freshly fallen red maple leaves with morning dew drops.

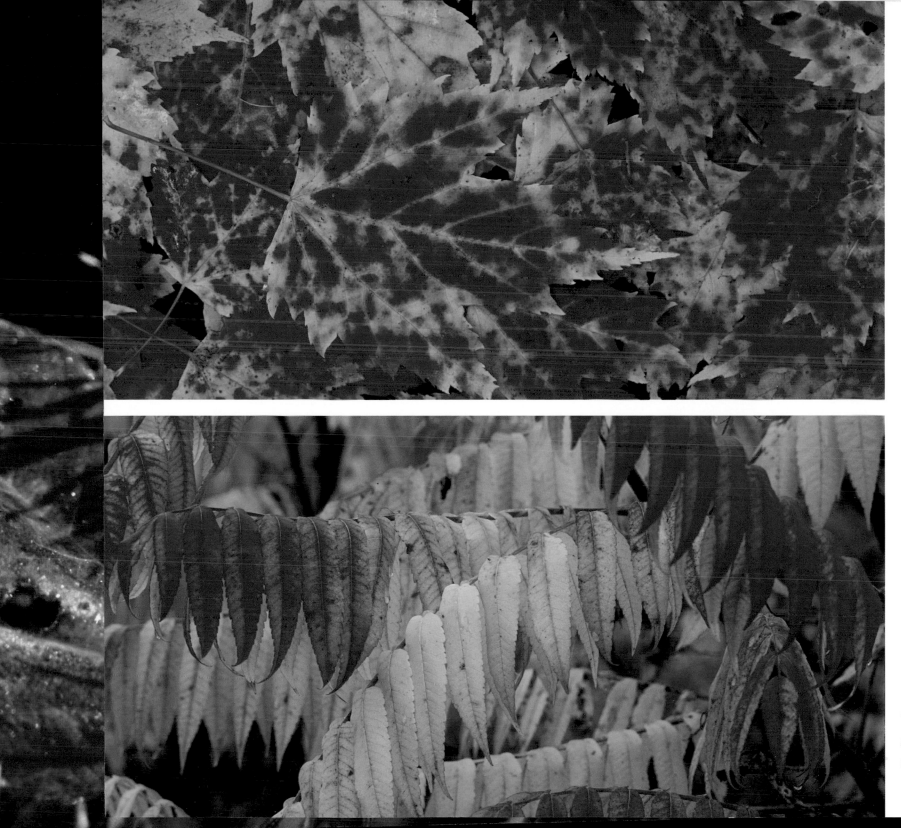

"How beautiful the leaves grow old. How full of light and color are their last days." John Burroughs

Top: Freshly fallen red maple leaves.
Bottom: Sumac leaves.

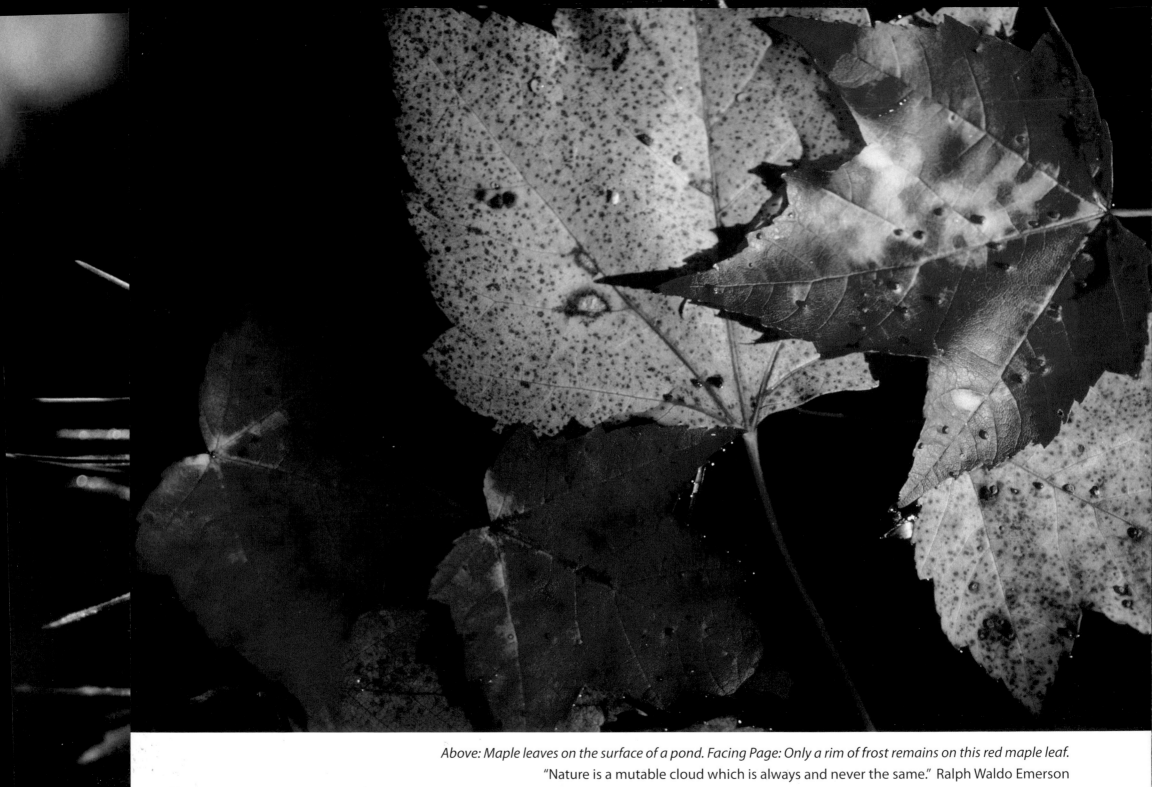

Above: Maple leaves on the surface of a pond. Facing Page: Only a rim of frost remains on this red maple leaf.
"Nature is a mutable cloud which is always and never the same." Ralph Waldo Emerson

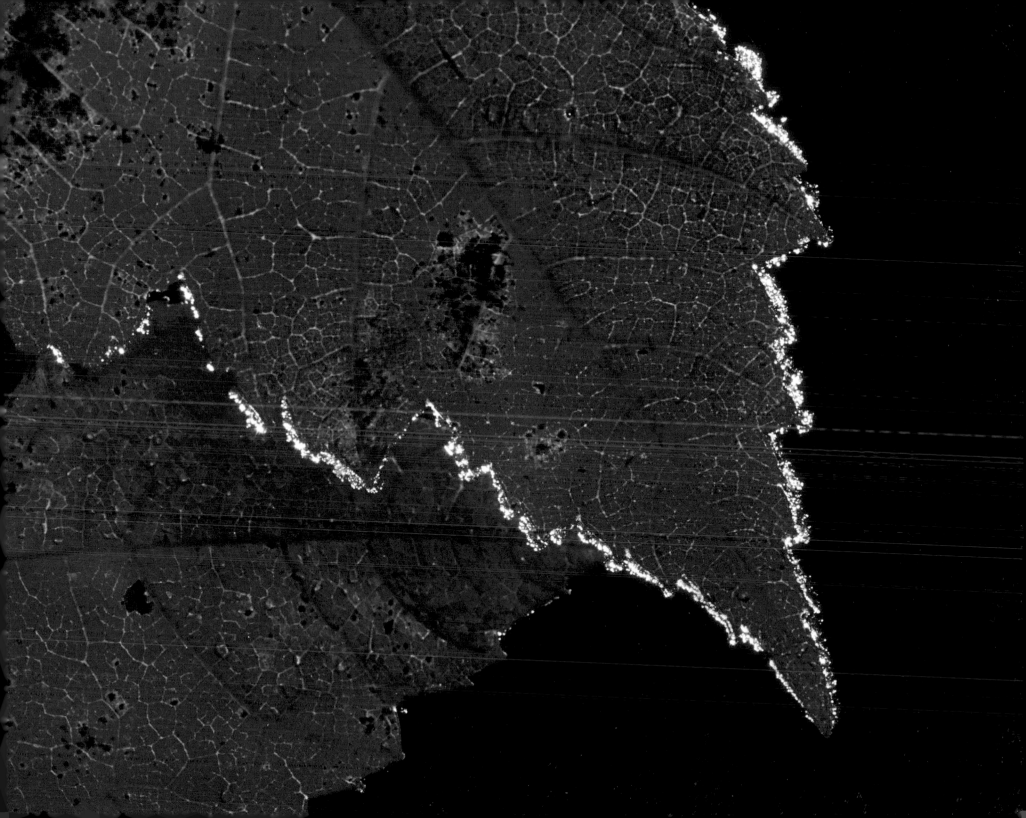

Right: Gray birch leaf.
Bottom: Red maple leaf with melted frost with a frozen drop of
water that has just begun to melt.

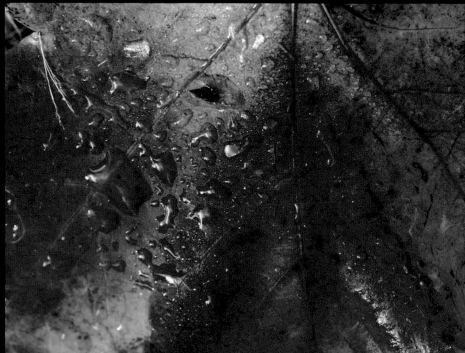

Tiny flecks of frost on red maple leaves.
"No spring nor summer beauty hath such grace as
I have seen in one autumnal face" John Donne

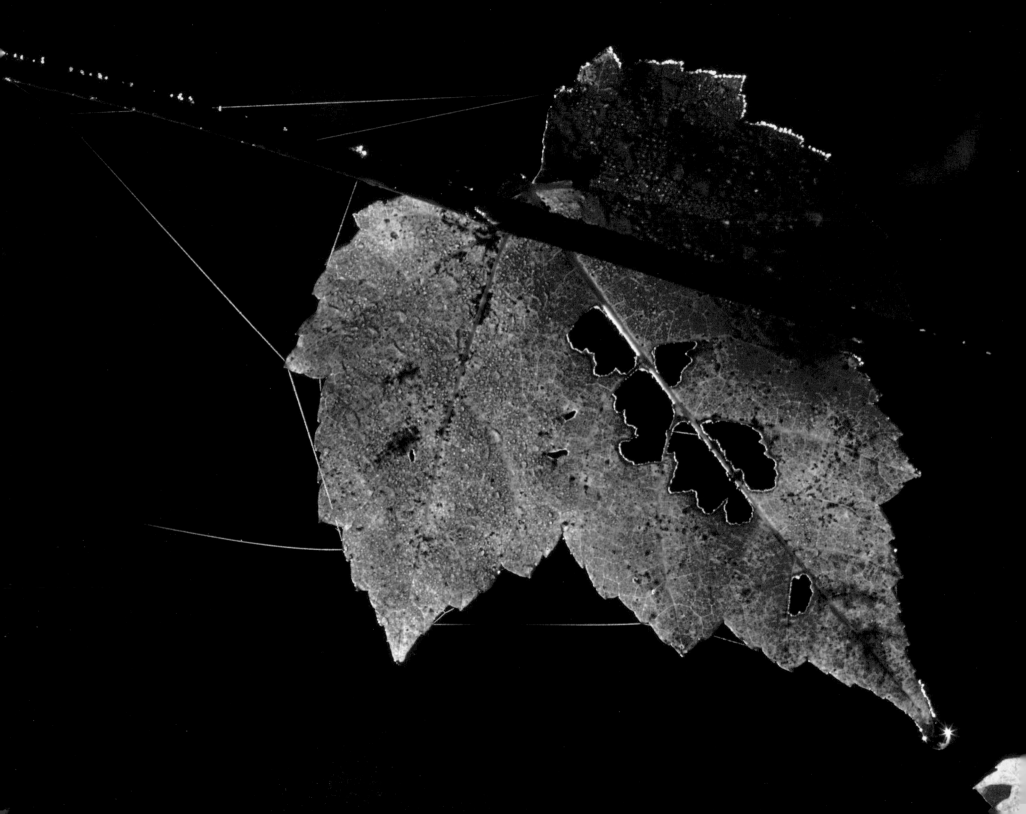

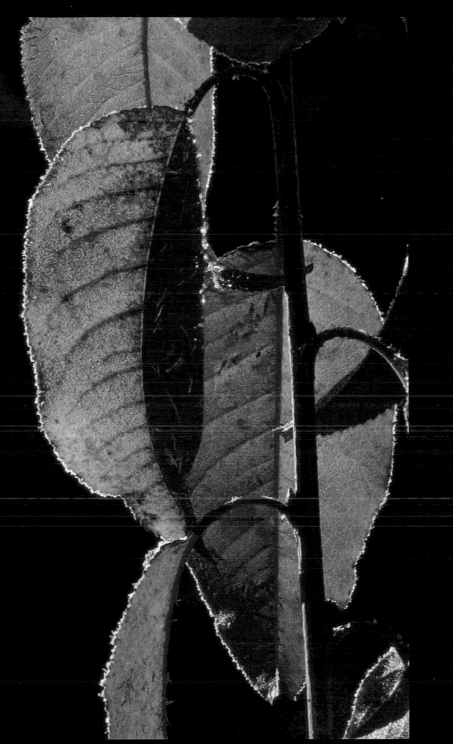

"The true poet knows more about nature than the naturalists because he carries her open secrets in his heart."
John Burroughs

Left: Frosted choke cherry leaves.
Facing Page: Red maple leaf with water drop and dewy spider webs.

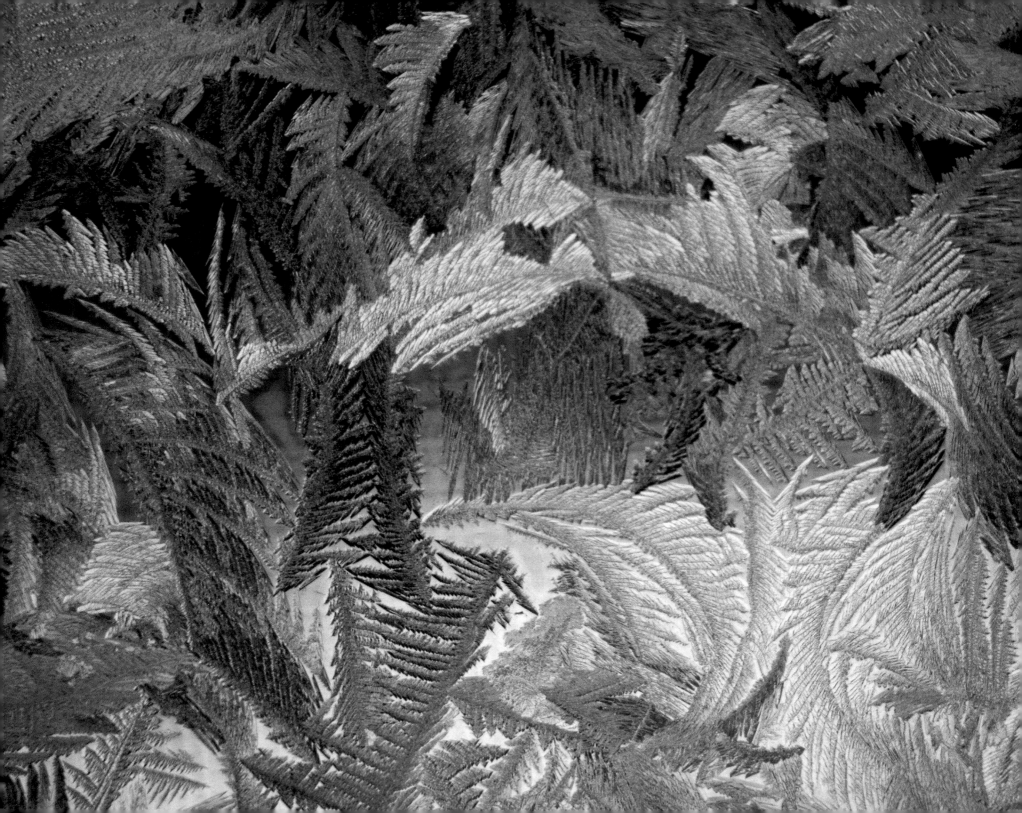

Ice

Moments fashioned from ice create an ambience of fantasy that is rarely seen in most Adirondack subjects. Frost and sleet transform trees into forests of silver. Swirls of ice on a window pane appear like crystalline ferns floating in space. Icicles look like works of glass sculpture. All forms of ice remind me of Thoreau's words, "The question is not what you look at, but what you see."

Sometimes I frame ice very close in my photographs, which helps to give them abstract qualities. Other times, I include a small portion of the surrounding environment so that reality gives identity to the surreal ice.

Splashing drops of water freezing on adjacent rocks start the growth of streamside icicles. Water dripping down these icicles causes them to elongate until their ends touch the current, where they flatten into structures that resemble feet.

Spring icicles frequently hang from melting ice sheets that cover a stream during winter. In late fall there is no ice sheet, and icicles develop on rocks, fallen branches or wherever else freezing drops of water attach themselves. At best, the icicle season is short. A warming sun causes these works of art to slip from their moorings and be lost forever.

Ice ferns on a window.

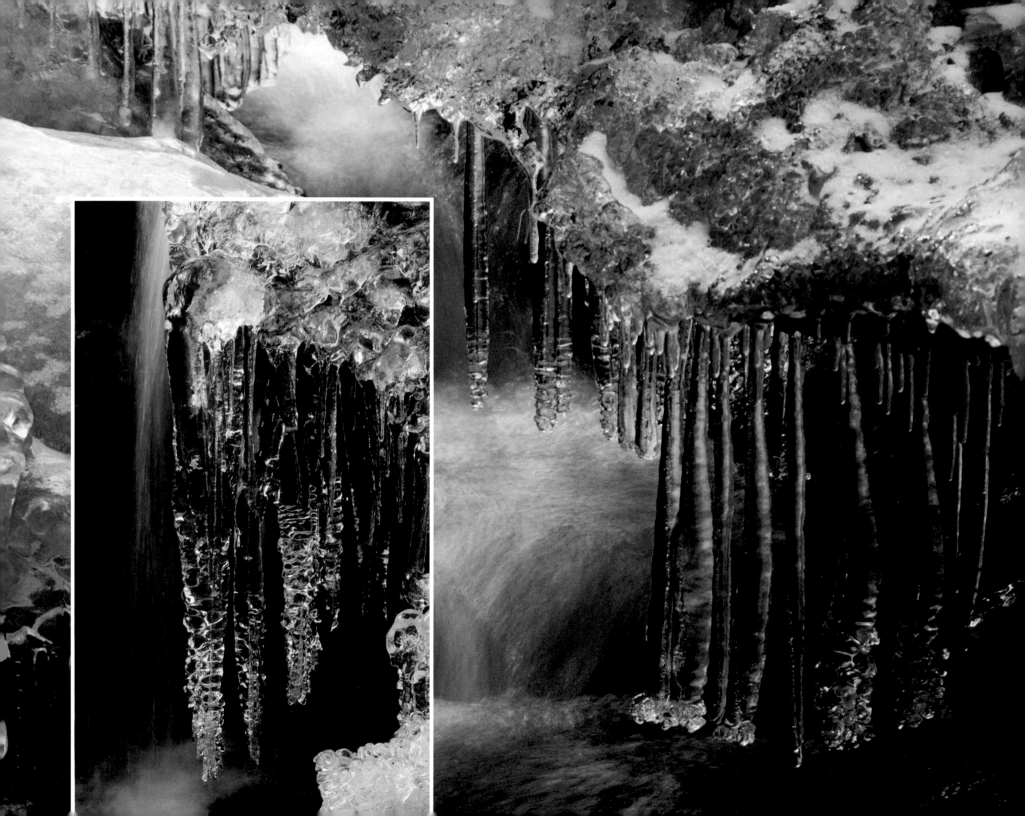

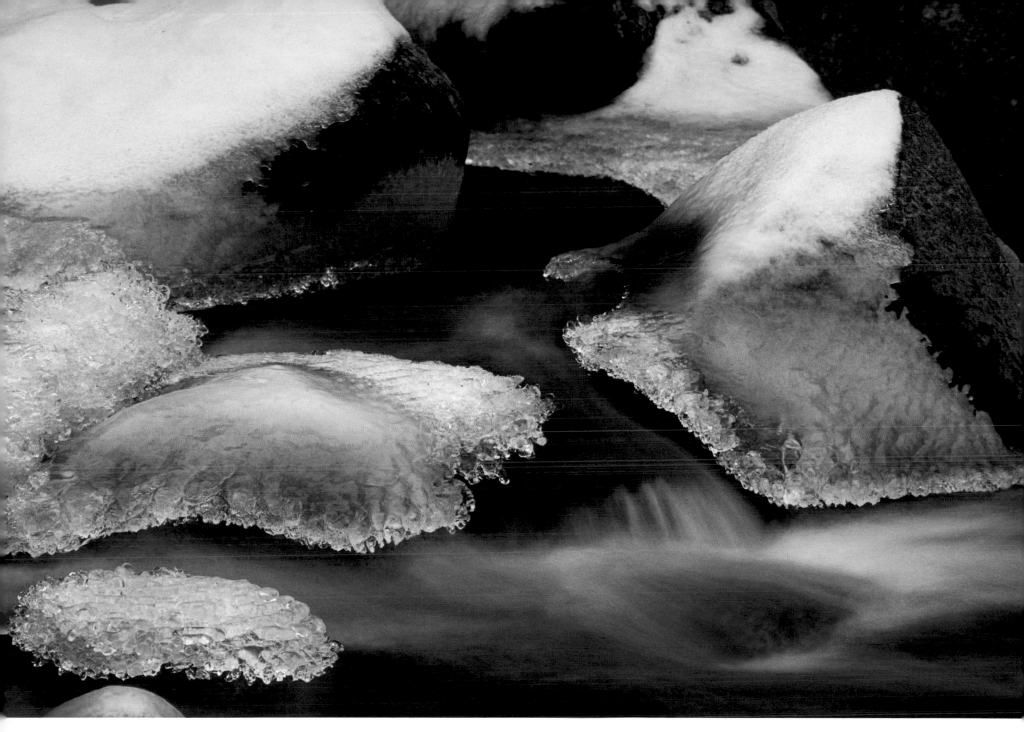

Icicles and ice caps on rocks along a stream, near Lake Placid.
It's just ice, but nature designs it distinctively.

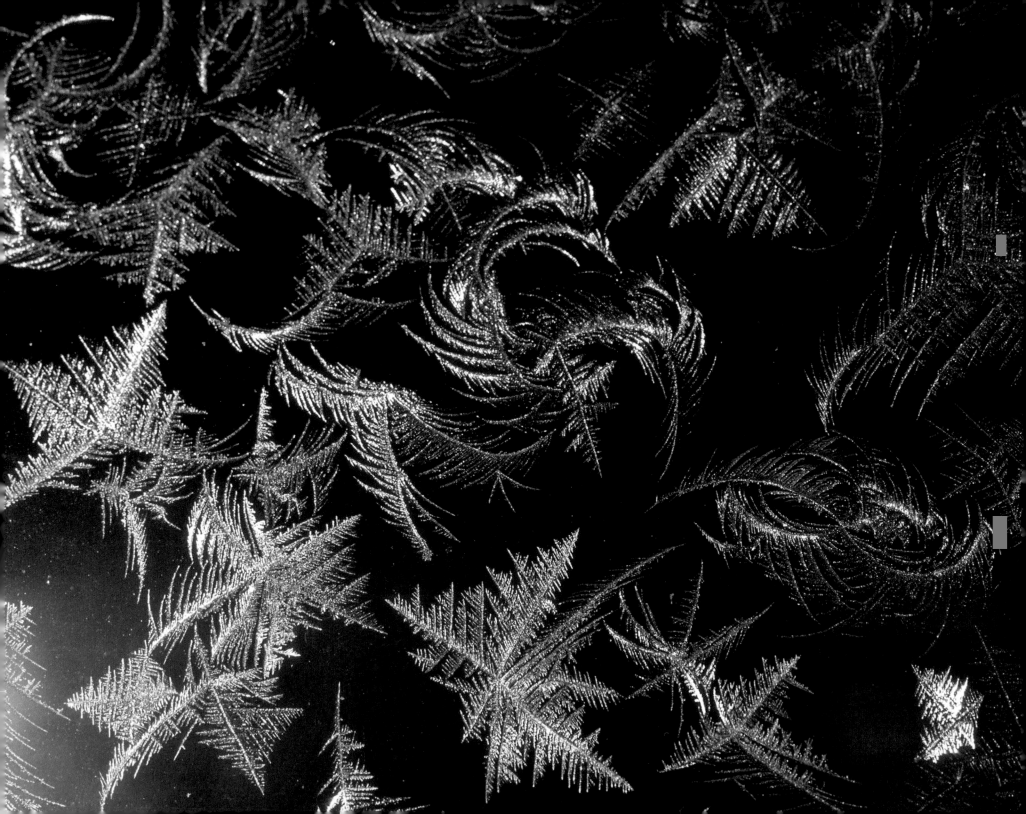

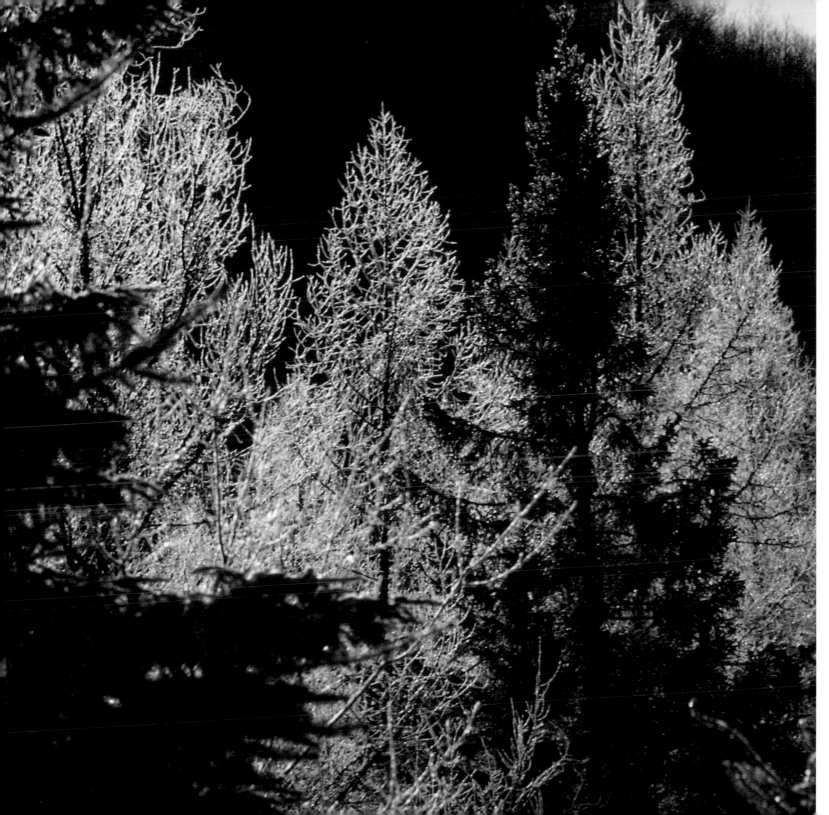

Left: Tamarack trees glisten with ice in early light, near Vermontville. Facing Page: Fragile ice ferns on a window.

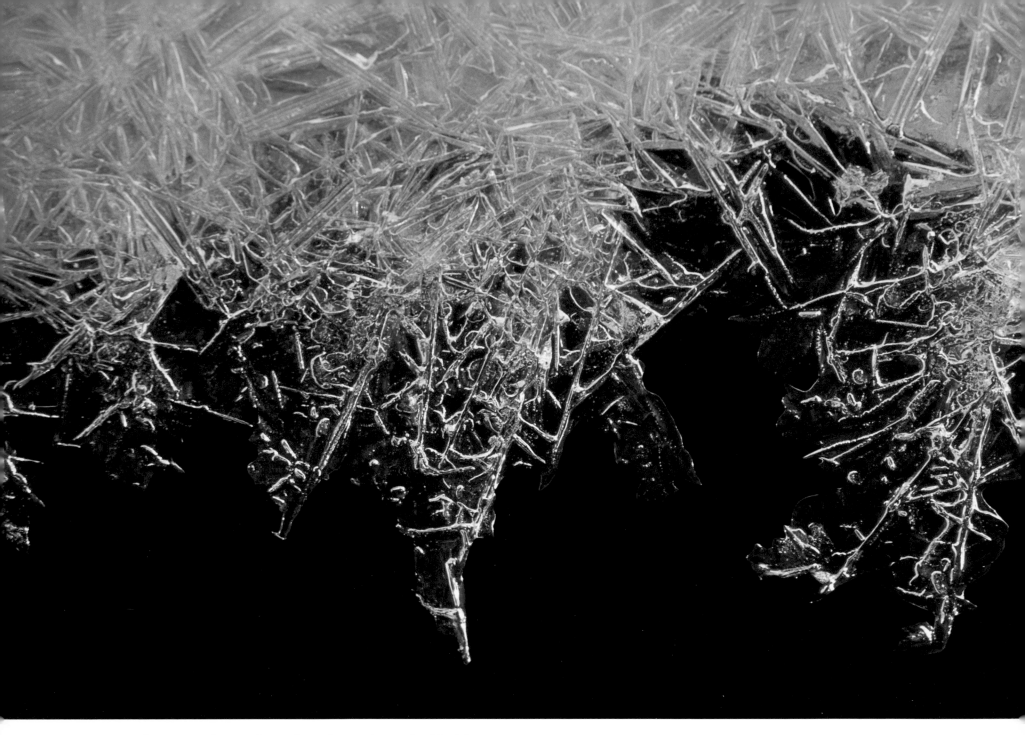

Fragile ice tentacles on the surface of a pond, near Paul Smiths.
Ice growth is a delicate process.

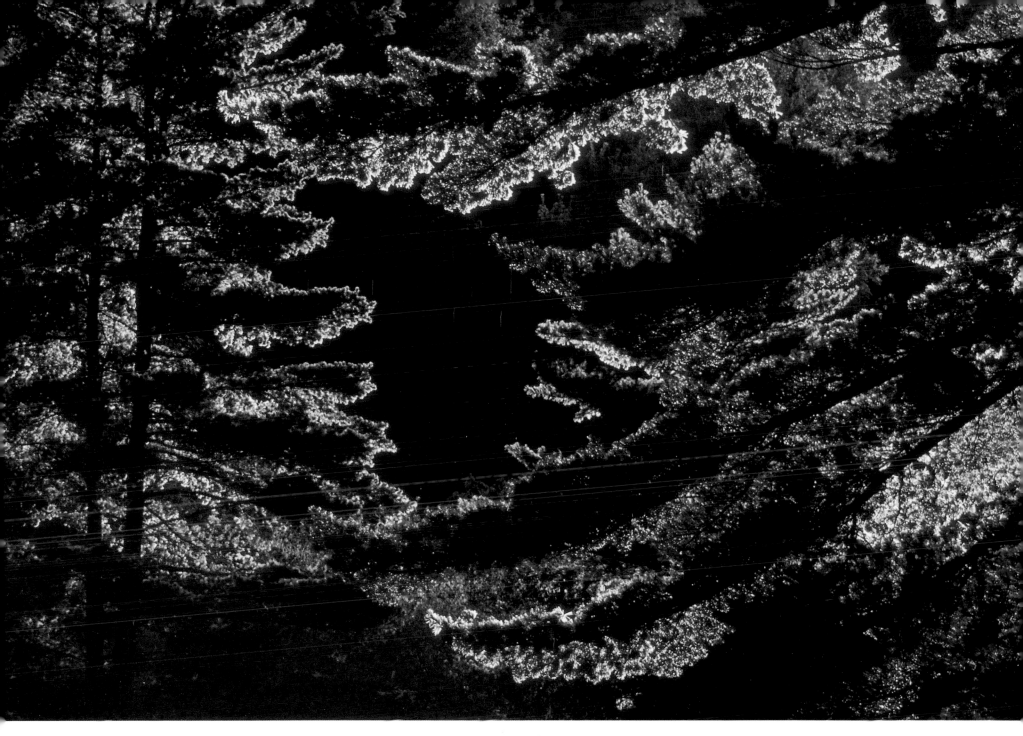

Frost on the branches of white pine sparkle with sunlight from behind, near Paul Smiths.
Even trees cannot escape the whimsical brush of Jack Frost.

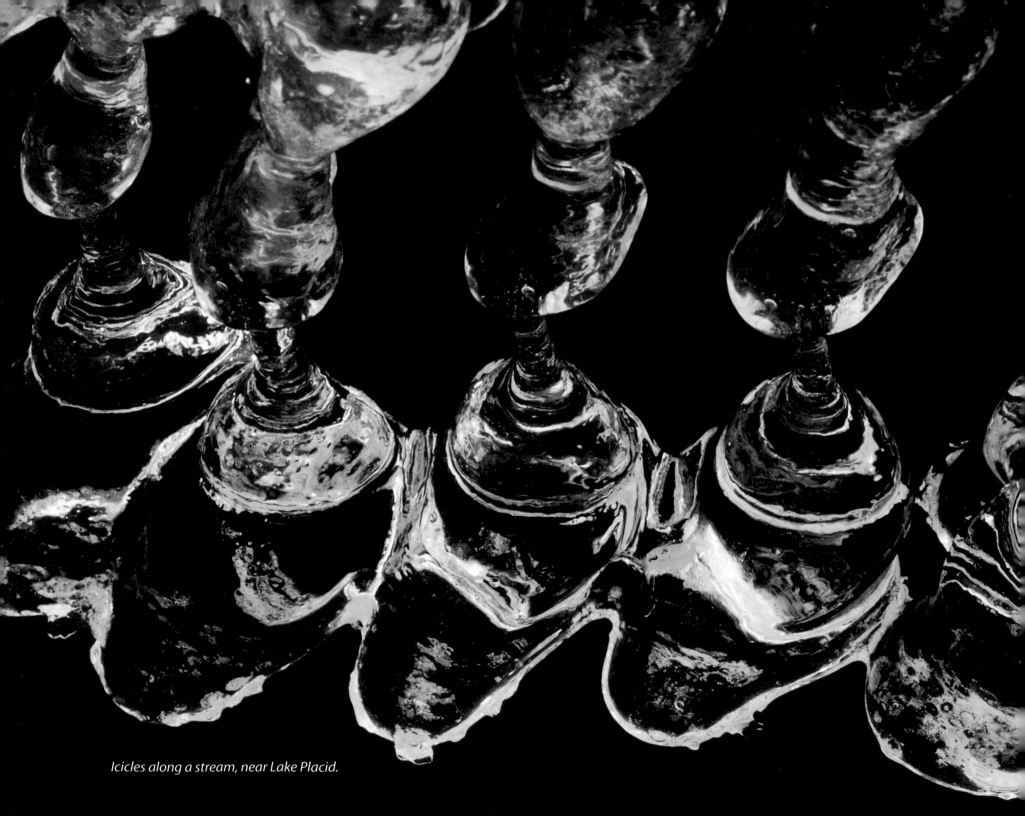

Icicles along a stream, near Lake Placid.

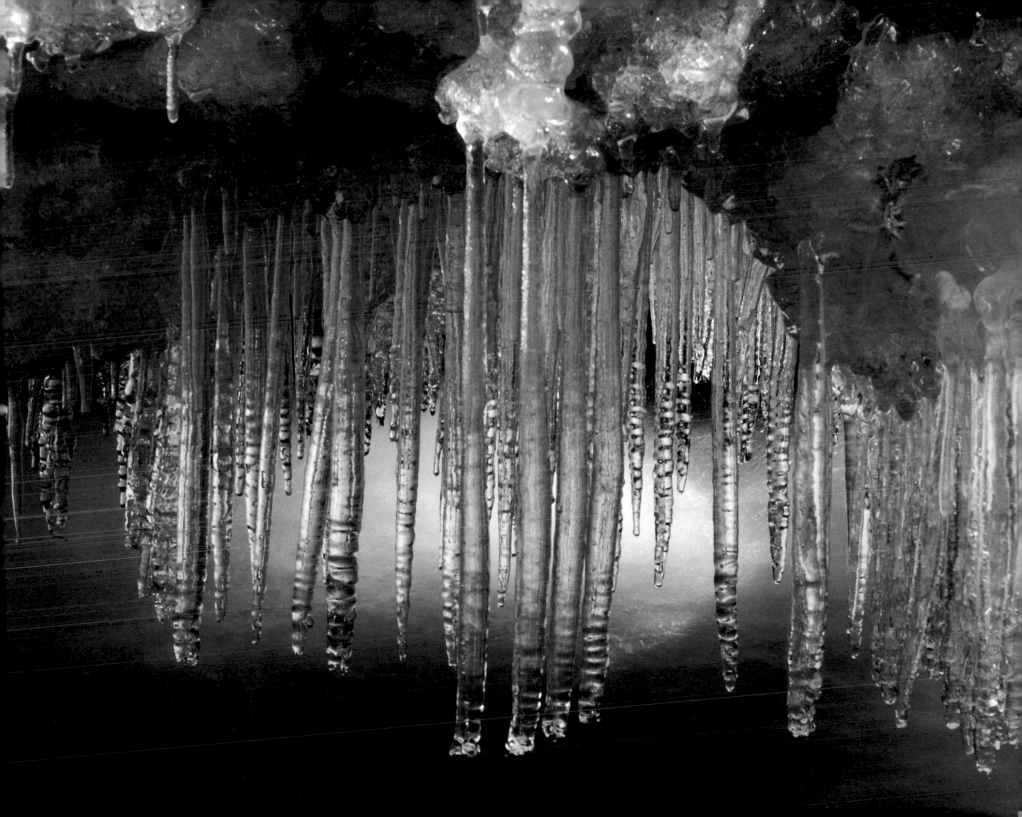

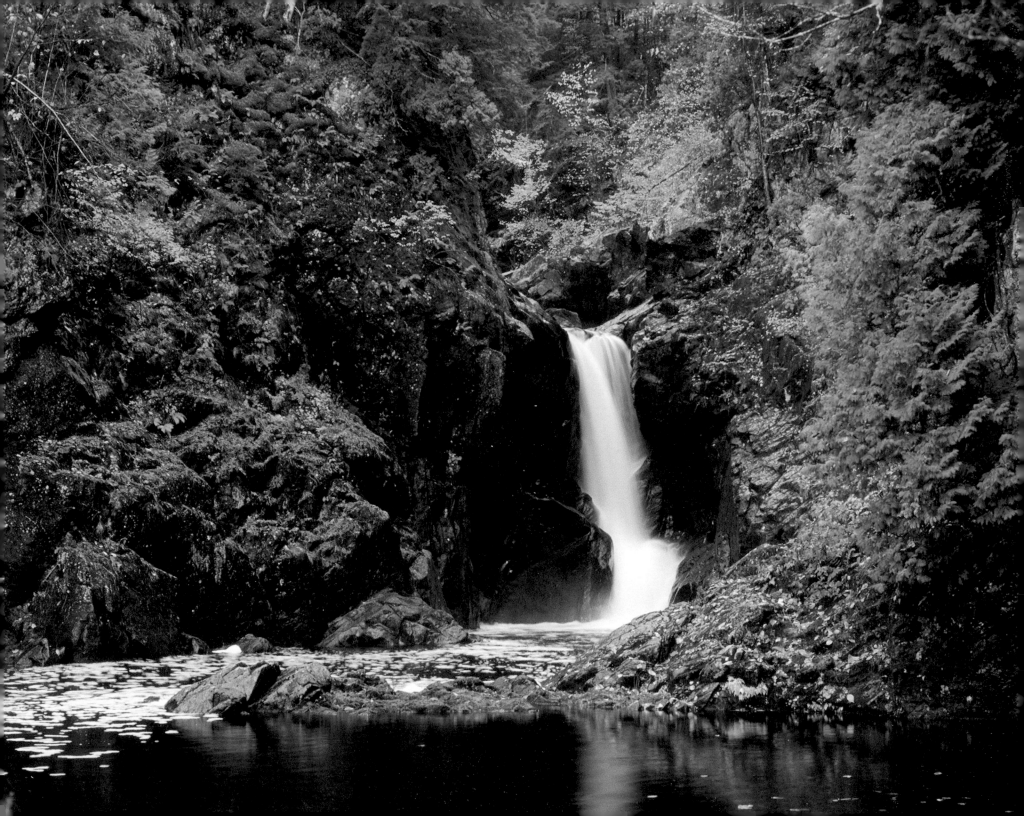

Water

FALLING WATER

The morning was fresh with dew. Tiny beads of water clung to spruce needles, flowers and blades of grass. With so many drops to photograph, I was looking for one that might represent all the rest; a drop seen in its first relationship with the earth.

At the edge of a marsh I found the drop I was looking for, hanging from a blade of grass like a minuscule Christmas ball. Looking closer, I saw a jewel-like reflection of leaves in the tiny sphere of water. Quickly, I set up my camera and carefully took two pictures. I moved my tripod closer. One of its legs touched the blade of grass, and the drop fell from its tenuous position. It had begun its journey to the sea.

Like invisible nets, spider webs catch and hold hundreds of dewdrops. Evenly sized and spaced, dewdrops can make a strand of webbing look like a pearl necklace. Spider webs glisten for only a few minutes before sunlight evaporates their fragile dew.

It took many years to find what I consider the grandest prize in the world of small water: a dragonfly drenched with dew. Cool temperatures and the weight of water on wings make flight impossible. I took great care setting up my camera, since such special moments are rare indeed.

Walking carefully through a bog another morning, I noticed large drops of water trapped in the needle whorls of a small tamarack tree. It appears that tamarack needles catch falling raindrops and funnel them to the base of the whorl, where they merge into a larger drop. In this position, they look like precious stones framed in a green setting.

MOVING WATER

Moments with moving water come from riffles and pools, from lines of light flickering over submerged pebbles, from autumn colors blurring in currents, from rocks sculpted over many years, and from falls cascading over cliffs and down steep gradients.

Waterfalls exhibit a high intensity of beauty that is always present and provide continuous moments of splendor. Large ones attract the most attention, but I prefer those that are small, intimate and found deep in the woods – the ones that don't appear in guidebooks.

STILL WATER

A good time to visit a lake is morning, after the cold of an autumn night has forced the water to lose summer heat. Sunlight shoots water vapors with hues and tints. Islands emerge like battleships. And then, from the mist, a loon calls; perhaps far in the distance, perhaps startlingly close.

Water is a canvas on which land paints its images. Smooth, calm water reflects sharp, true pictures. A gentle breeze ripples these paintings into abstractions of color and motion.

Facing Page: Waterfall on the Saranac River, near Vermontville.

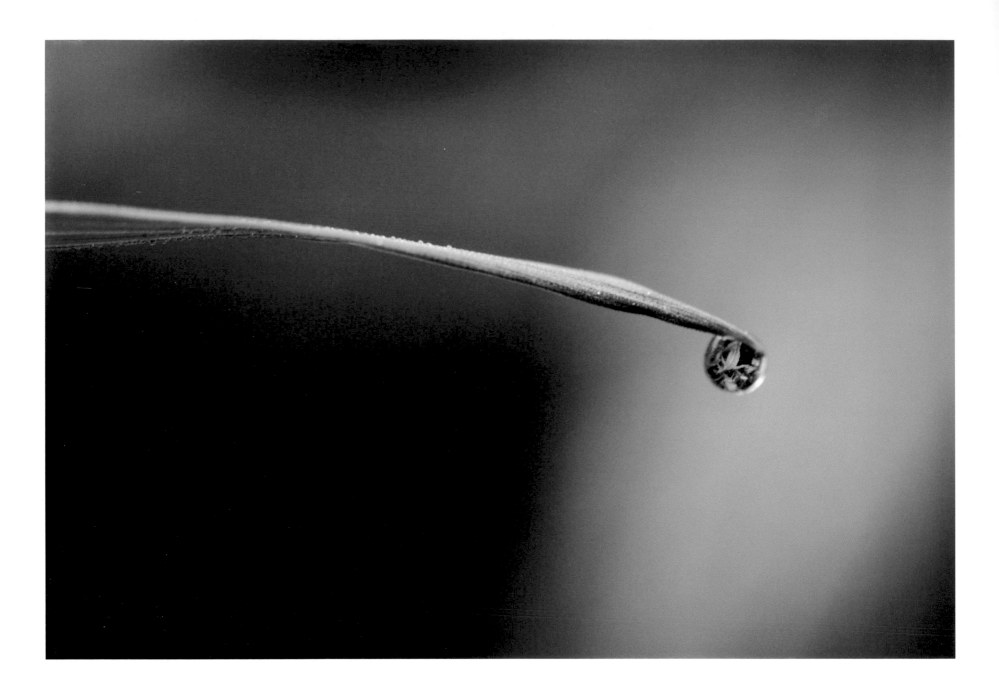

Above: Drop of water hanging at the tip of a blade of grass.
Facing Page: Raindrops caught in the needle whorls of a tamarack tree.

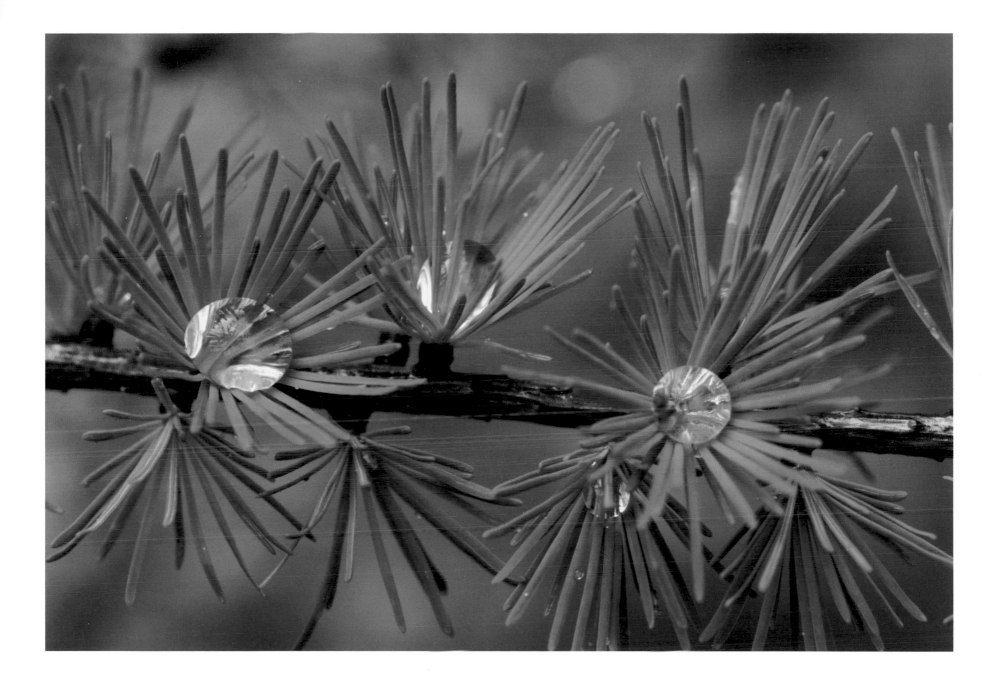

"Beauty...may be infinitesimally small or encompass the universe itself." Sigurd Olson

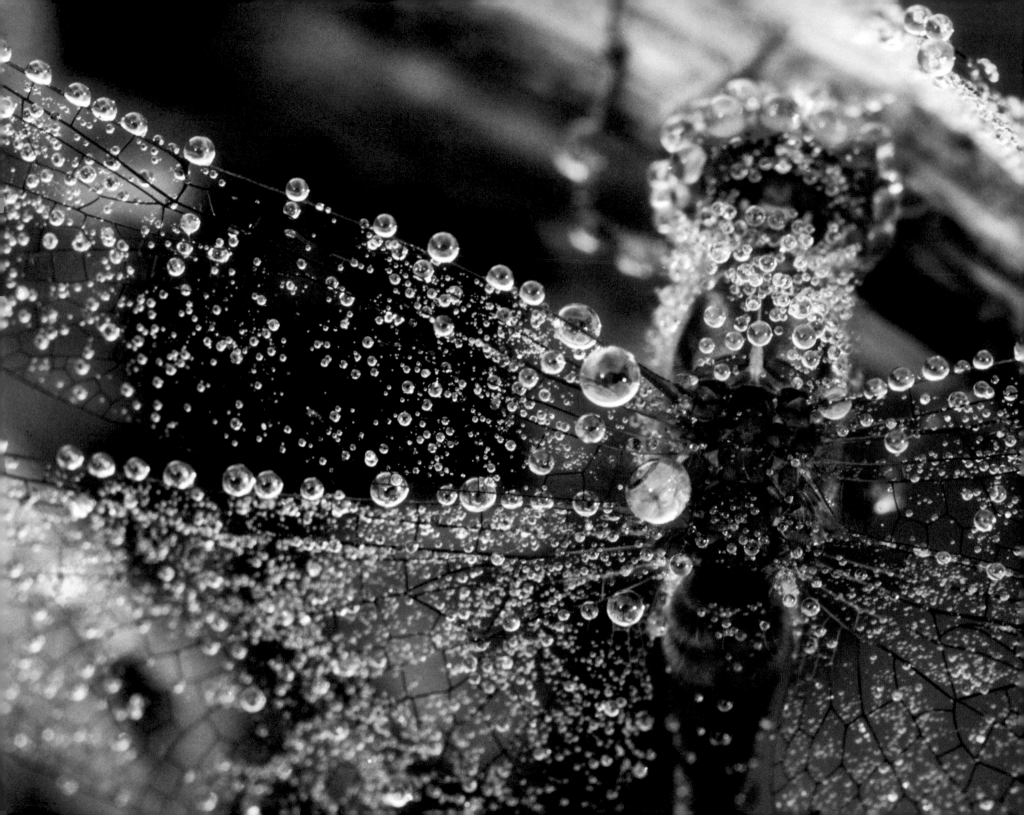

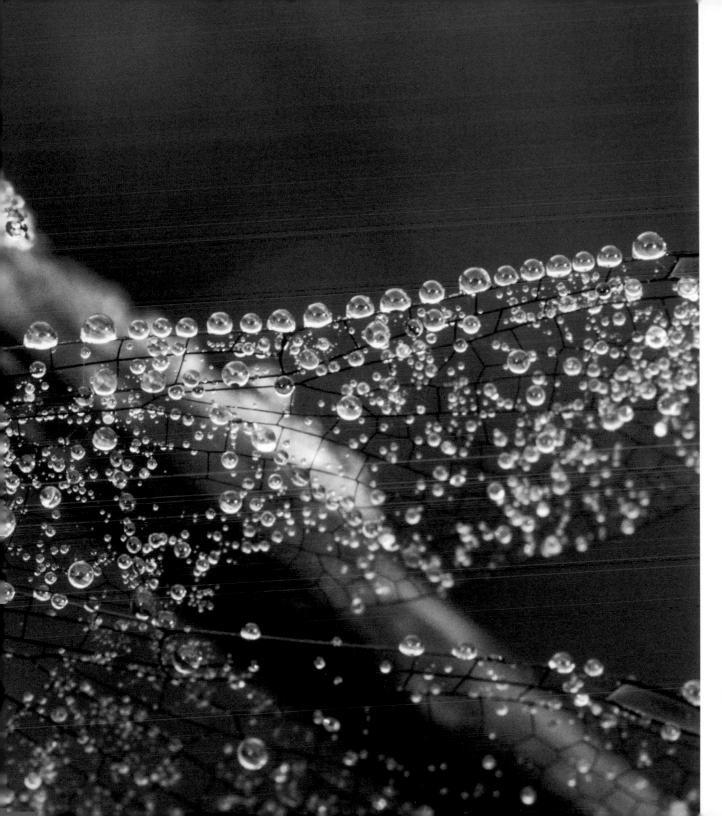

Nature placed the tiniest drops of water onto the fragile wings of this dragonfly to create this superb moment.

Wings of a dragonfly
beaded with dew.

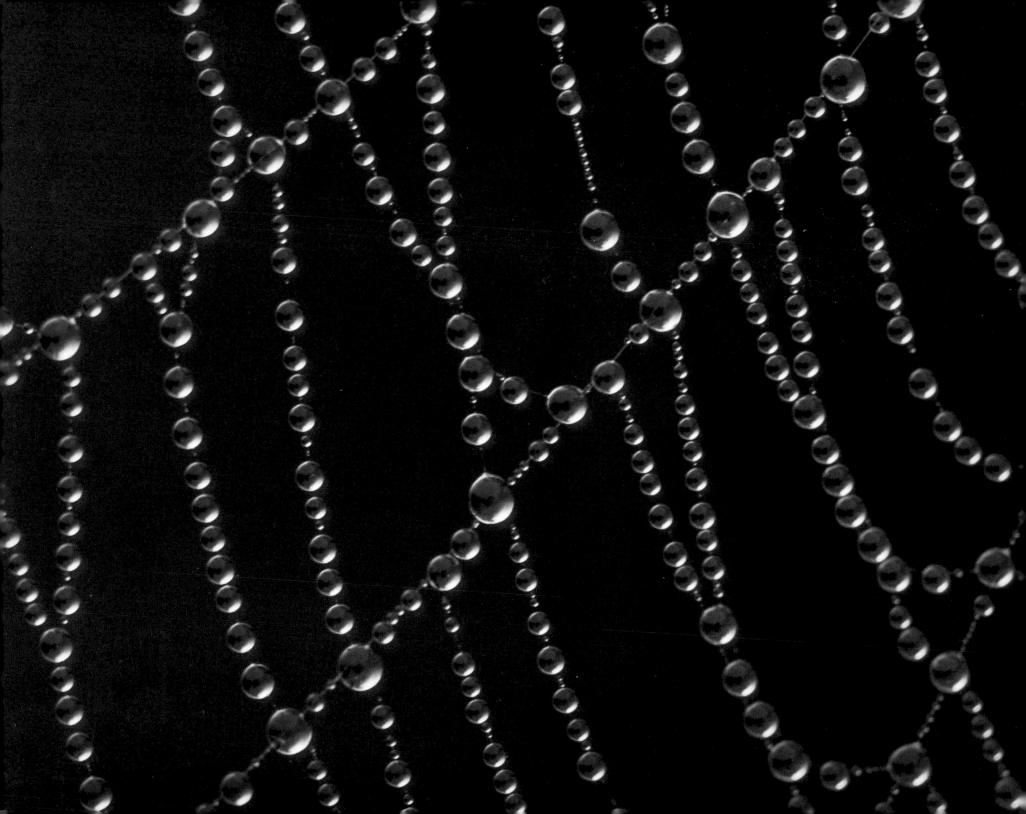

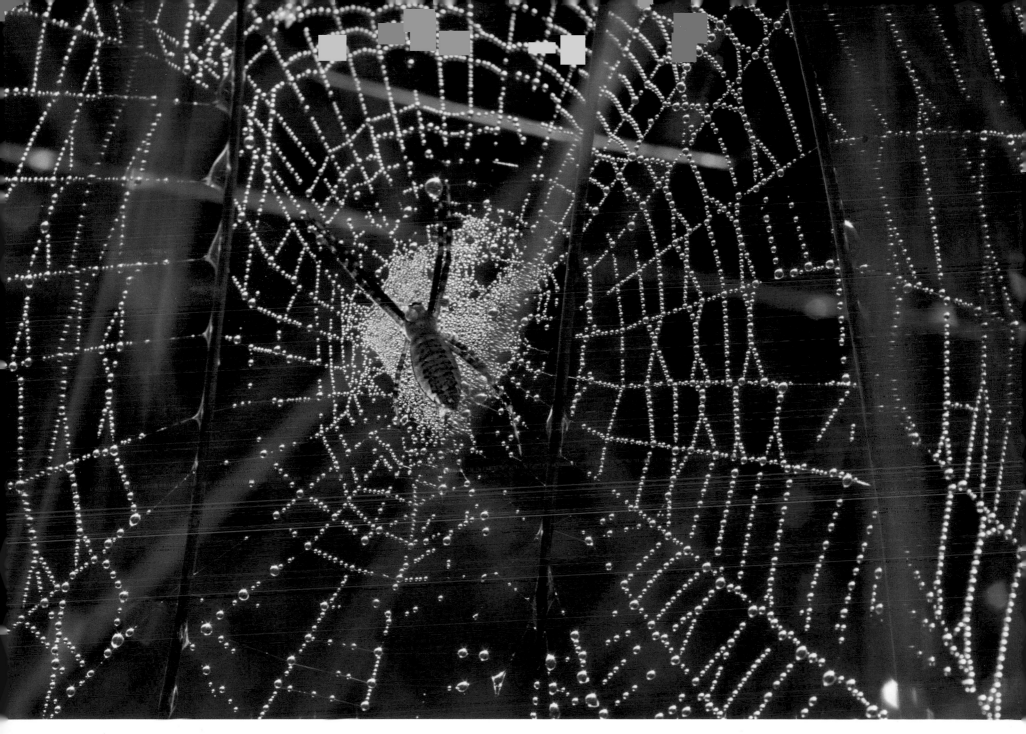

Above: A spider waits in his web for the dew to evaporate. Facing Page: A pearl necklace of a spider web covered with dew.

When dew drops evaporate from spider webs, the webs almost disappear.

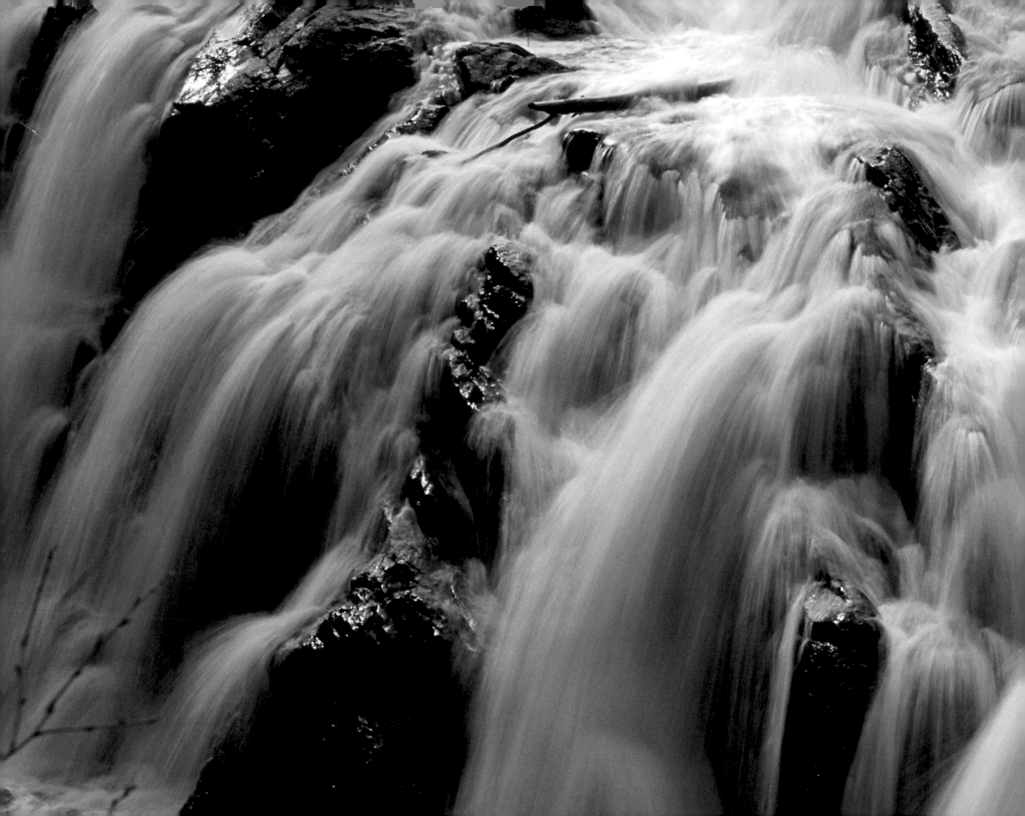

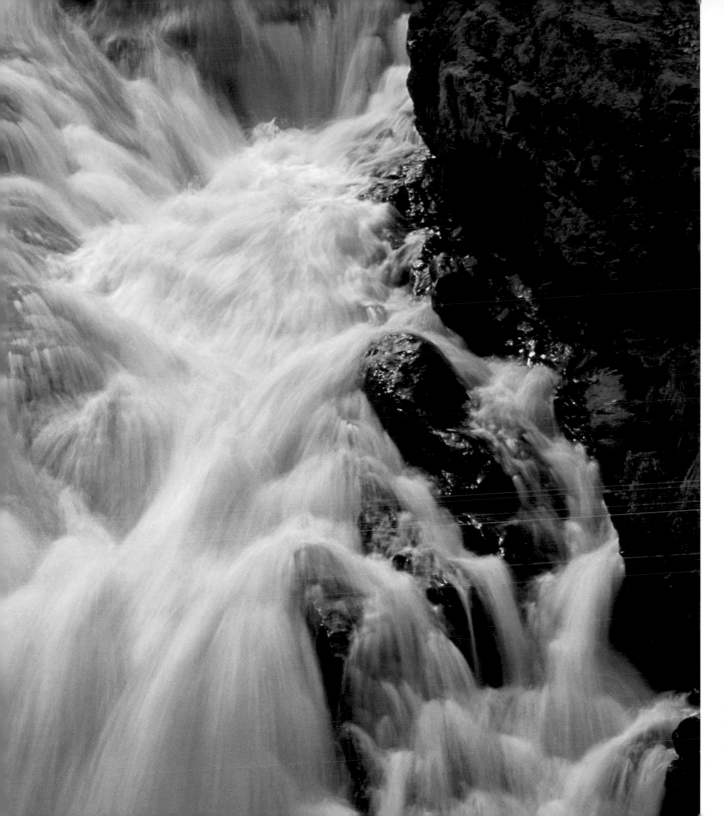

A waterfall is a wonderful place to let cares and worries flow away with the tumbling water.

Waterfall on the West Branch of the Ausable River near Wilmington Notch Campground, near Wilmington Village.

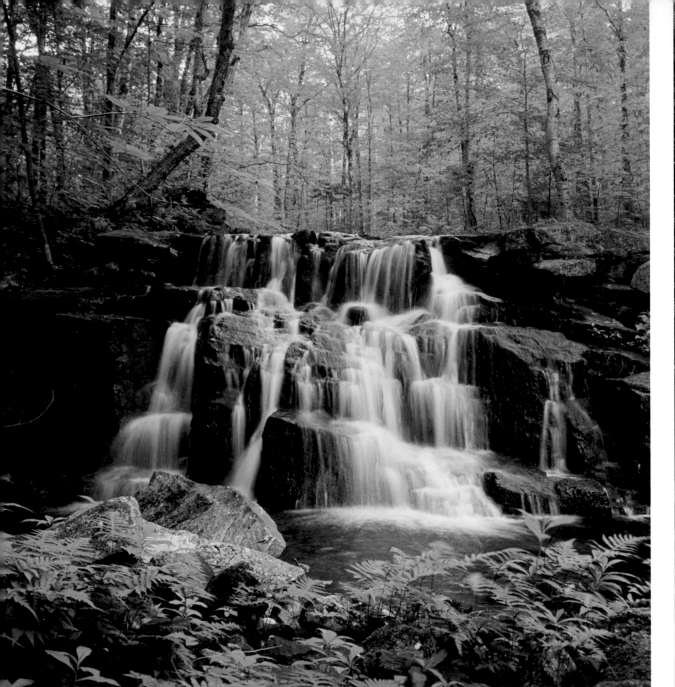
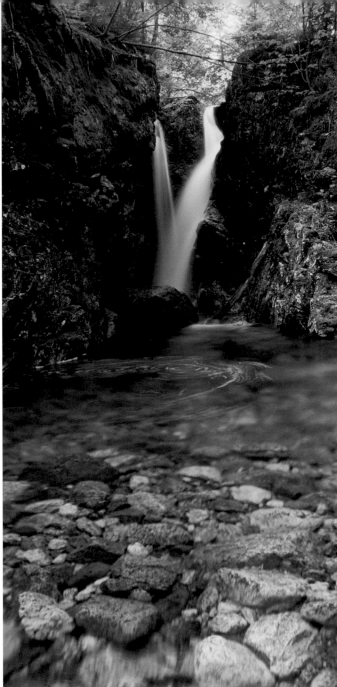

Above: Waterfall on trail to Peaked Mountain Pond, near North Creek Village. Right: Waterfall on Gill Brook, near Keene Valley. Facing Page: Small waterfall on Gill Brook, near Keene Valley.

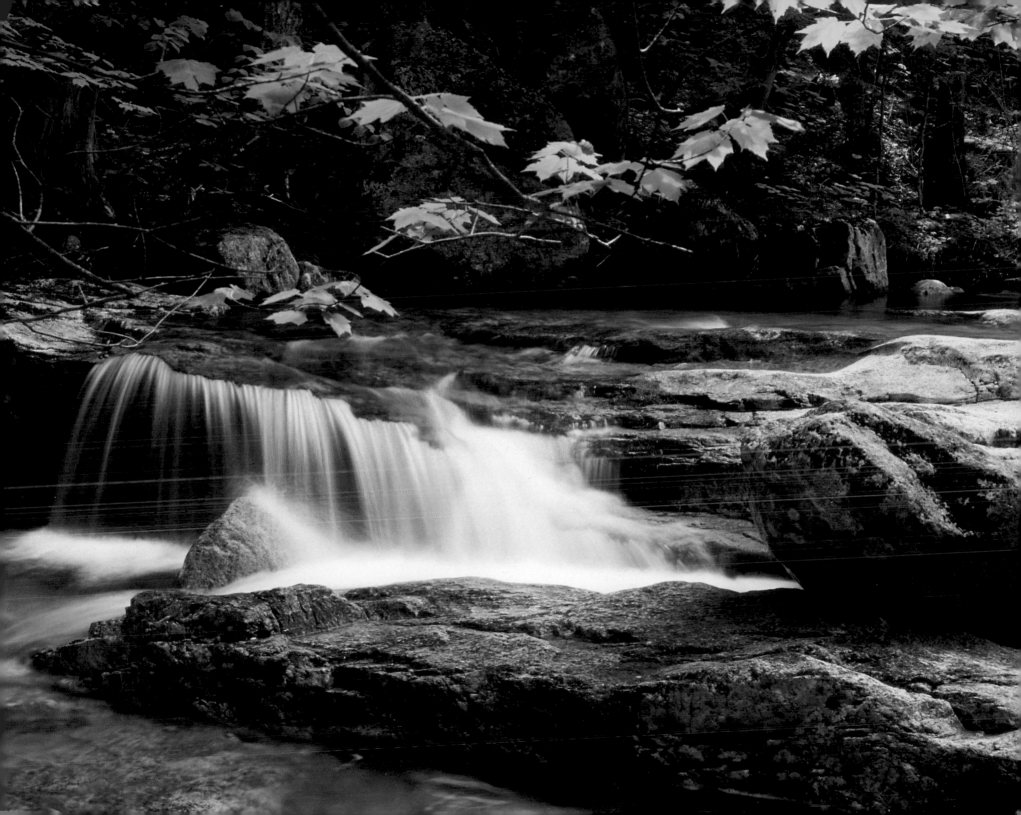

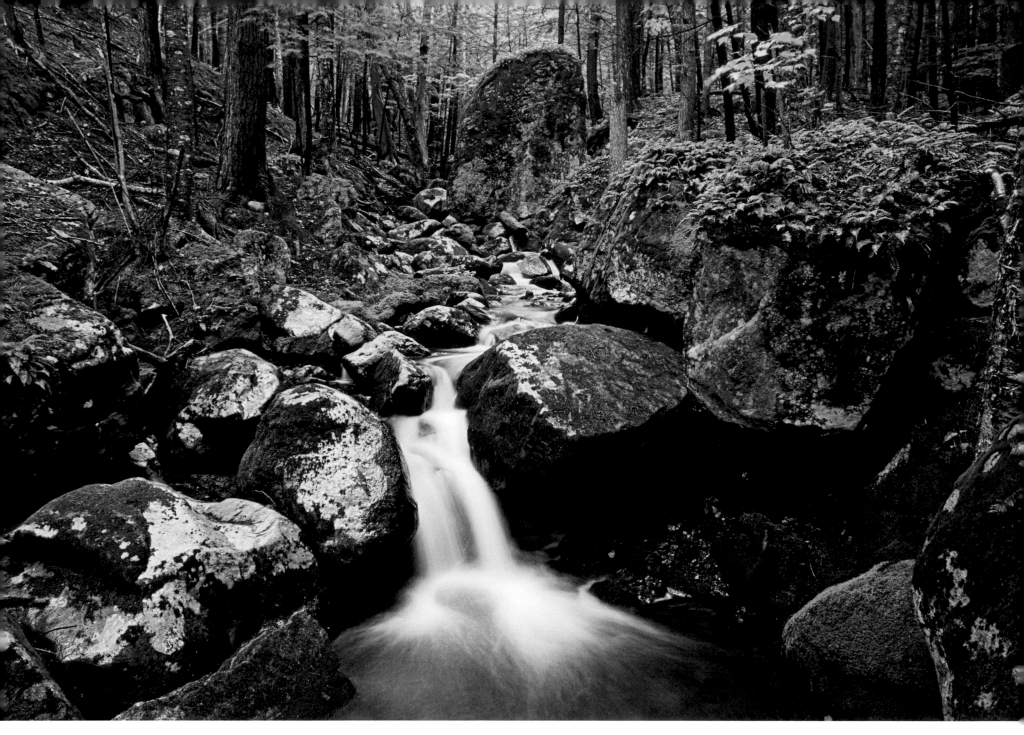

Small stream, near Keene.
Green lichens, mosses and ferns create an emerald stream.

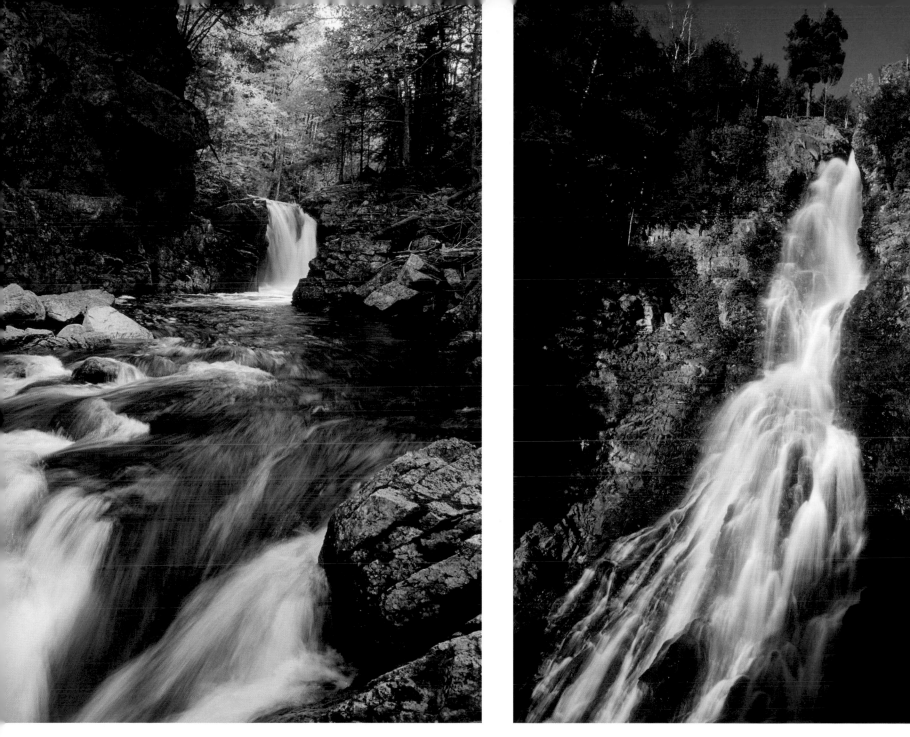

Above: Waterfall on the East Branch of the Ausable River, near Keene Valley. Right: The aptly named, Roaring Brook Falls, near Keene Valley.
Streams and waterfalls provide their own music.

Water is always beautiful, autumn adds something more.

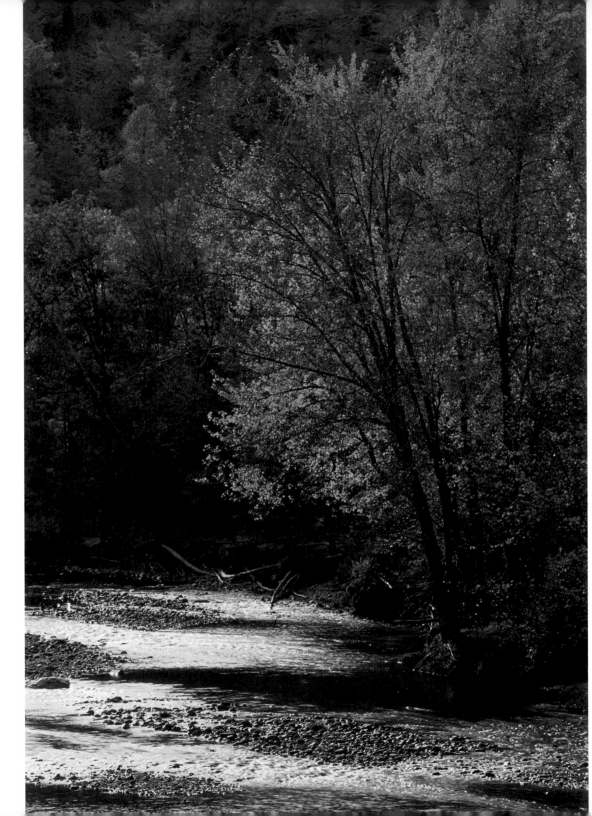

Right: Red maple catch the afternoon light on the bank of the East Branch of the Ausable River, near Keene.
Facing Page: Cascade Falls between Upper and Lower Cascade Lakes, near Keene.



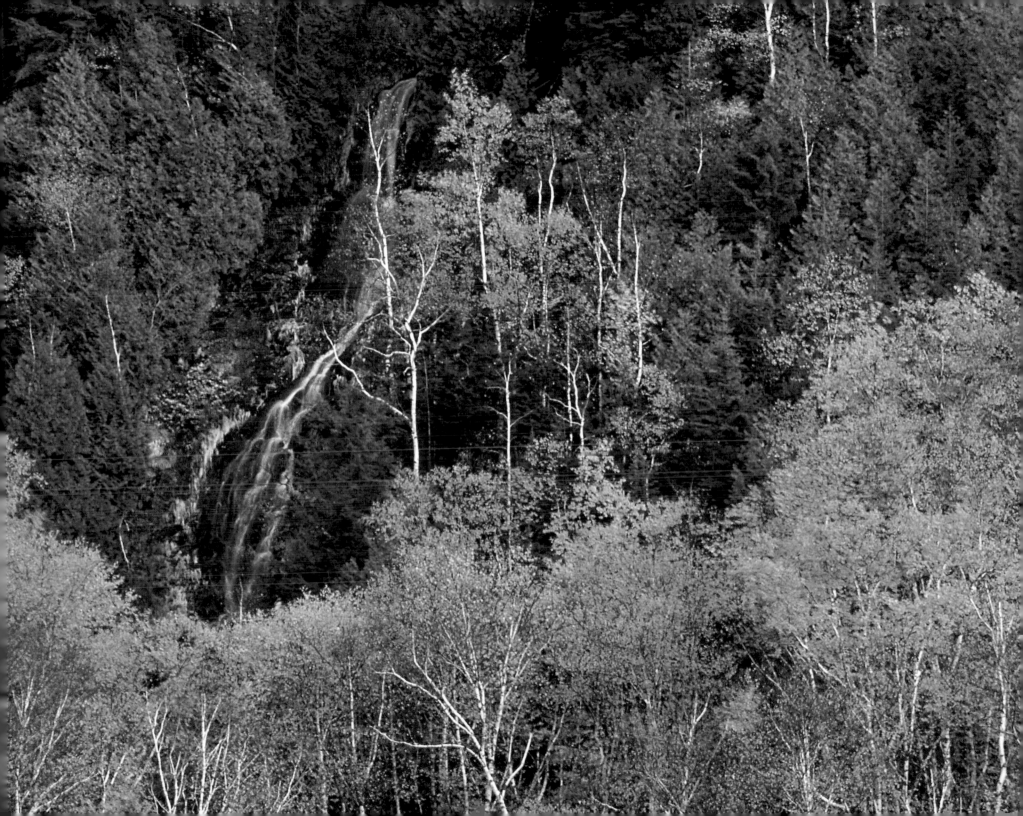

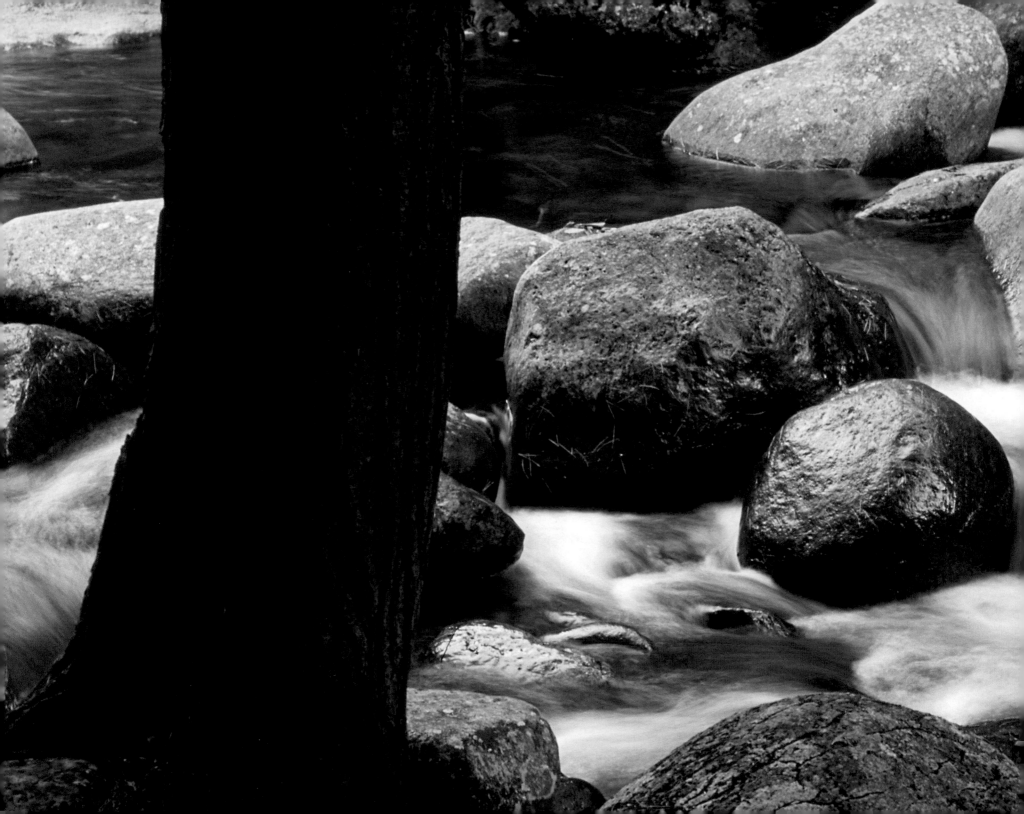

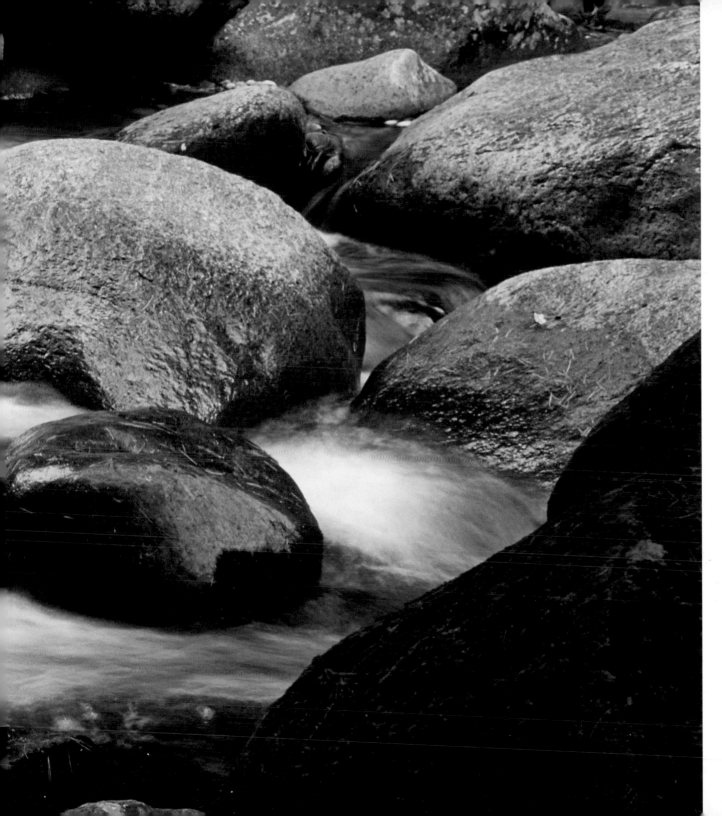

Flowing water smoothes, carves and moves rocks. This interaction between rocks and water creates riffles and pools.

Boquet River, near Keene Valley.

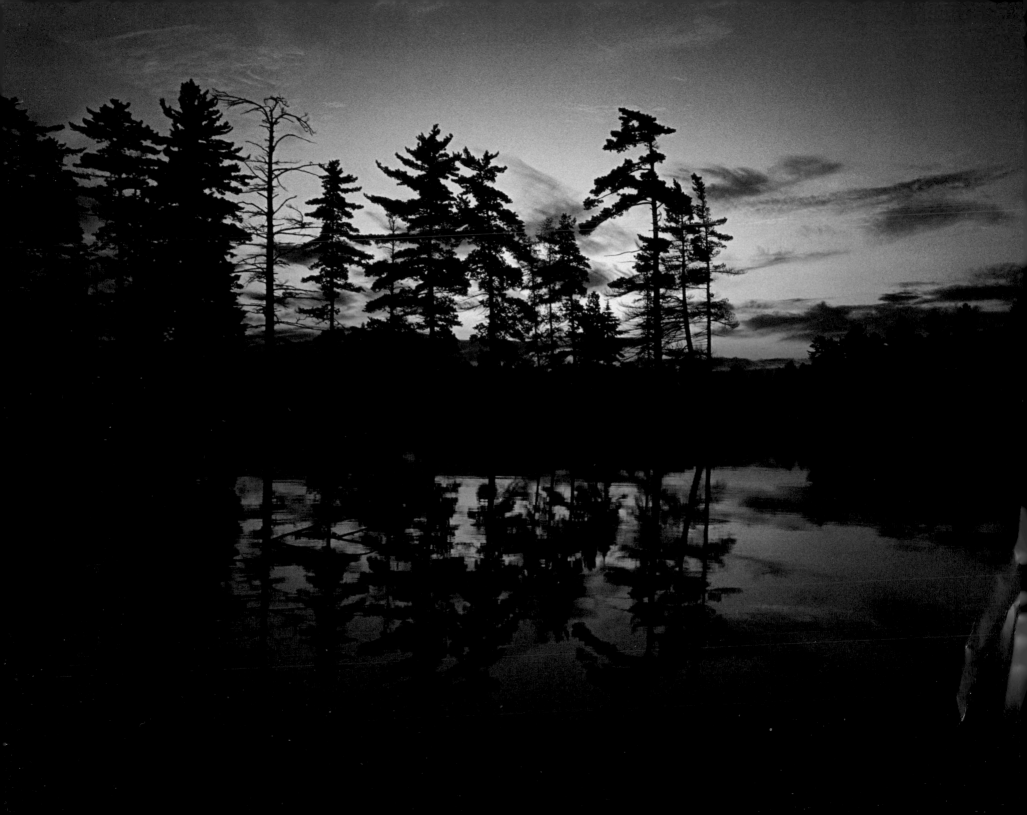

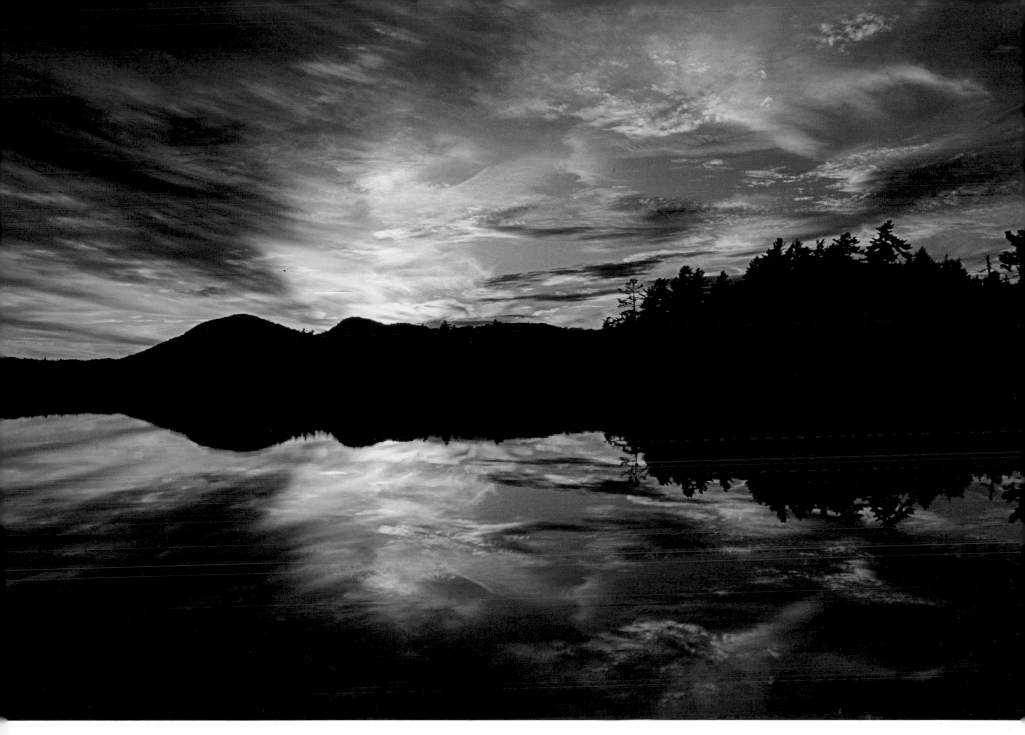

Above: Barnum Pond, near Paul Smiths.

Facing Page: White pine reflection at dawn – Francis Lake, near Old Forge.

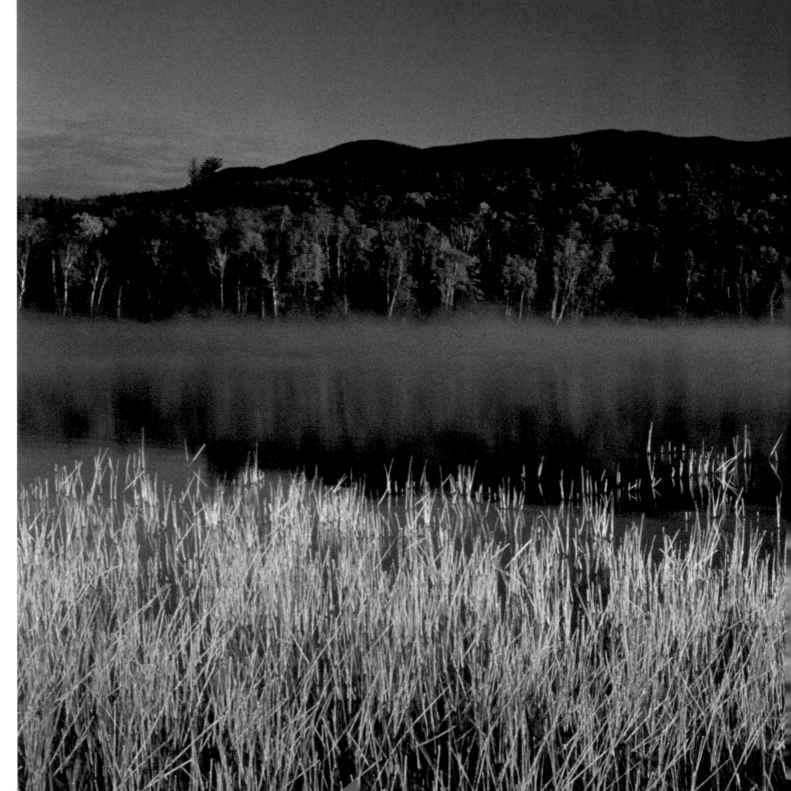

Visiting ponds in the early morning will ensure you don't miss some of nature's best moments.

Frosted grass and Whiteface Mountain at Connery Pond, near Lake Placid.

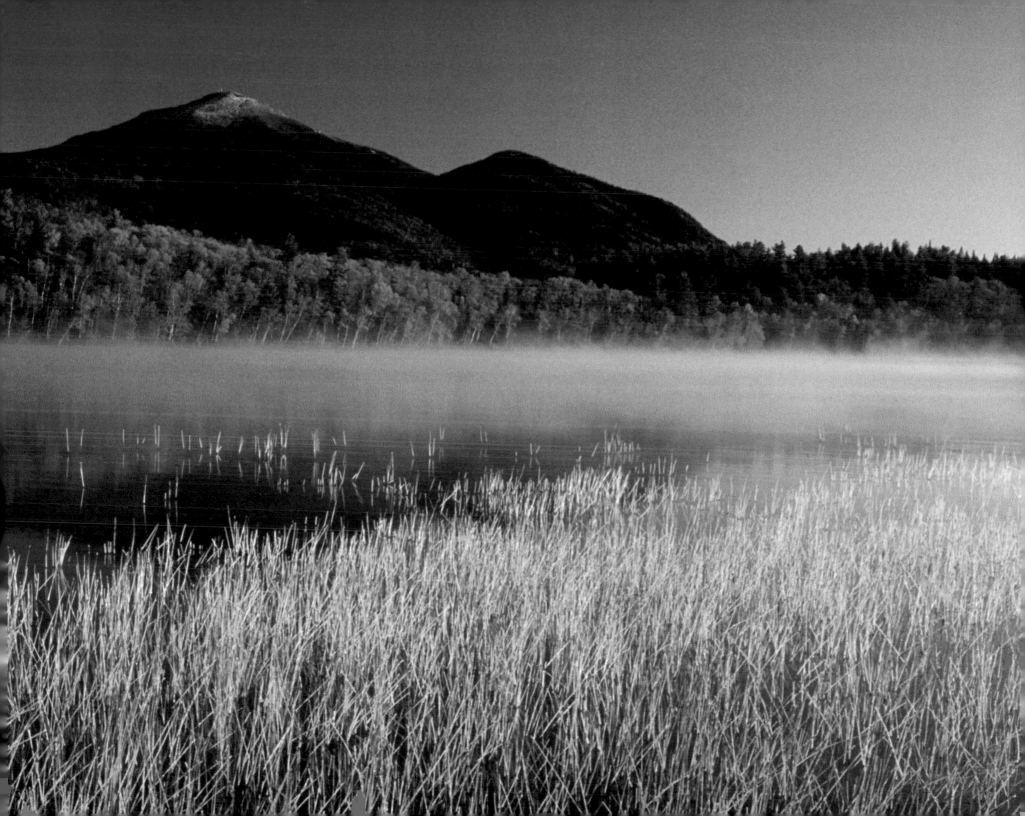

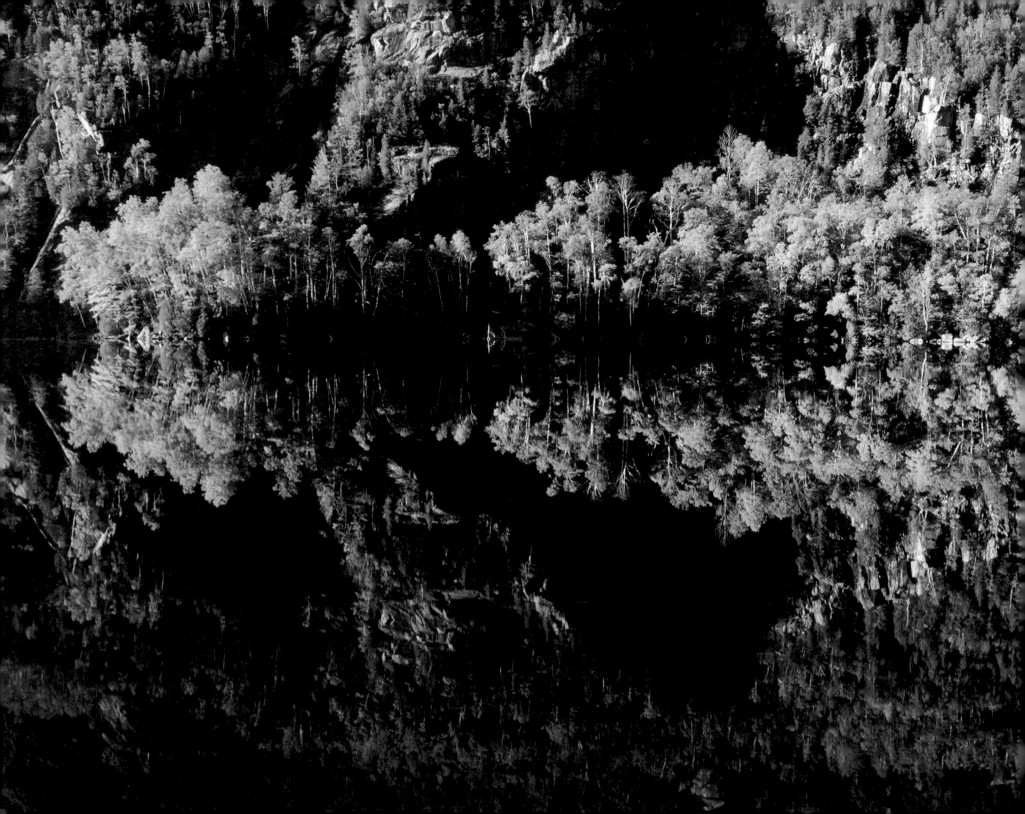

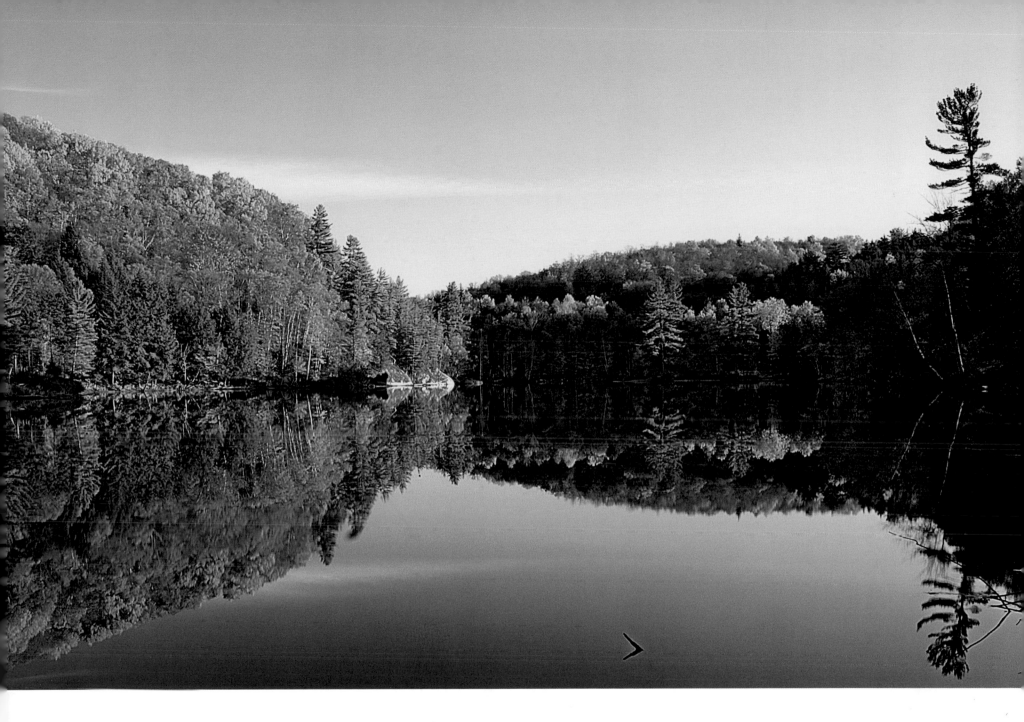

Above: Reflection at Mountain Pond – near Paul Smiths.
Facing Page: Reflection at Chapel Pond, near Keene Valley.

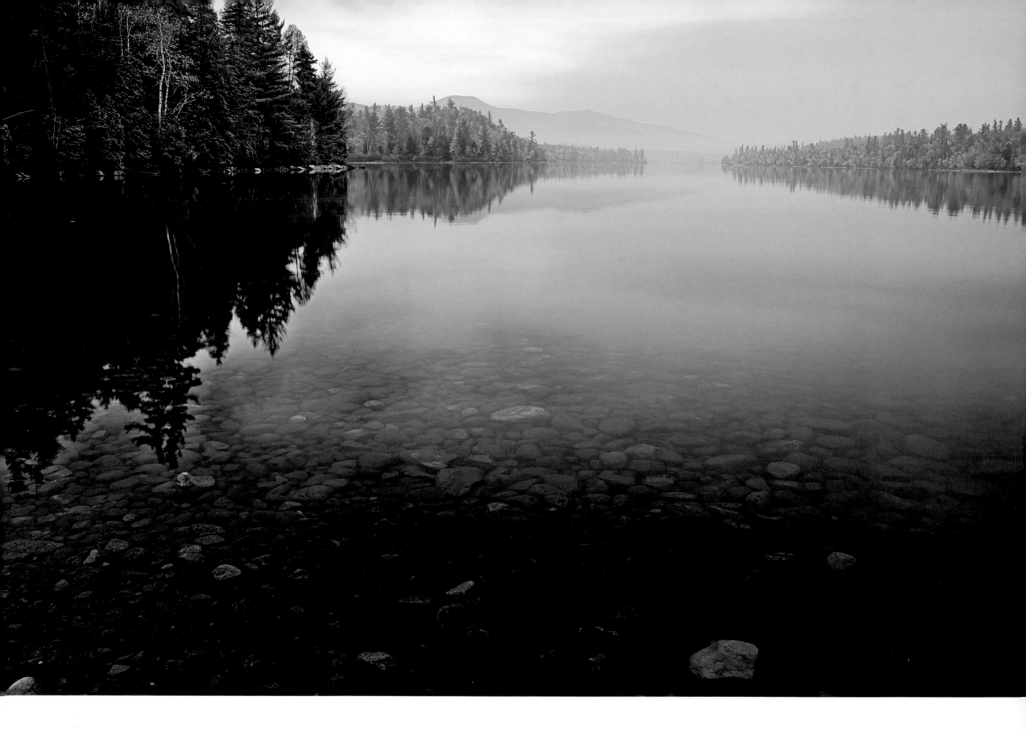

Above: Franklin Falls Pond, near Vermontville.
Facing Page, Left: Reflection on Union Falls Pond, near Vermontville; Right: Reflection on Mountain Pond, near Paul Smiths.

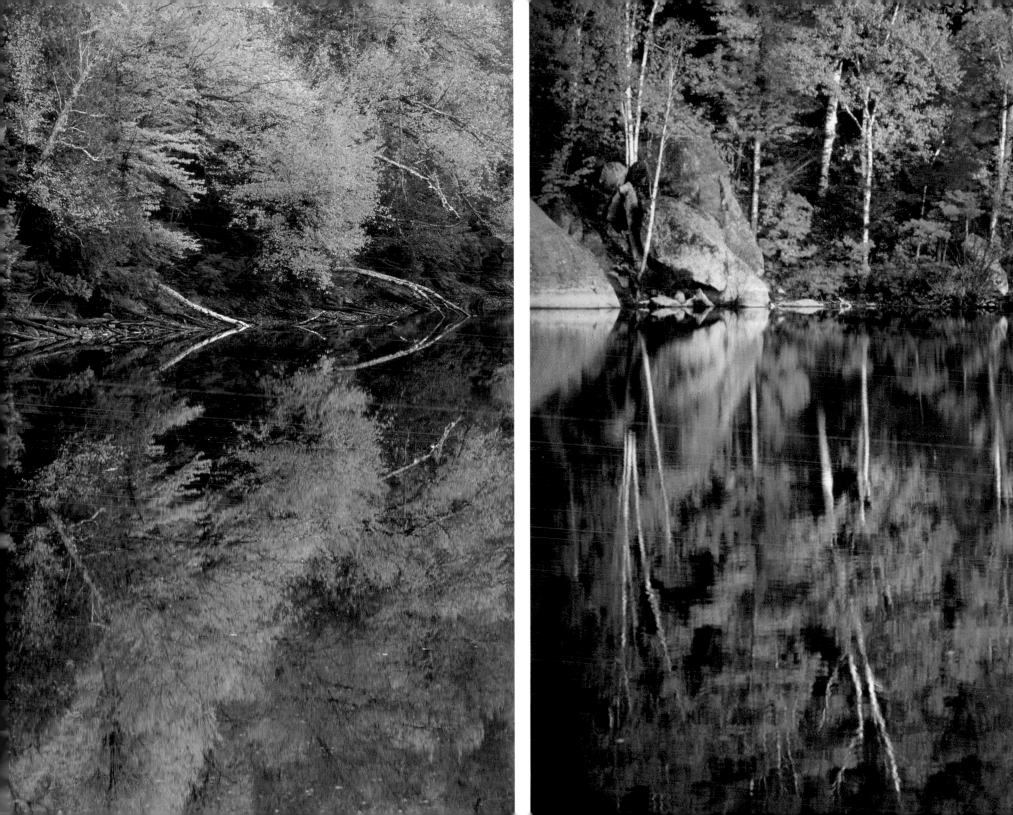

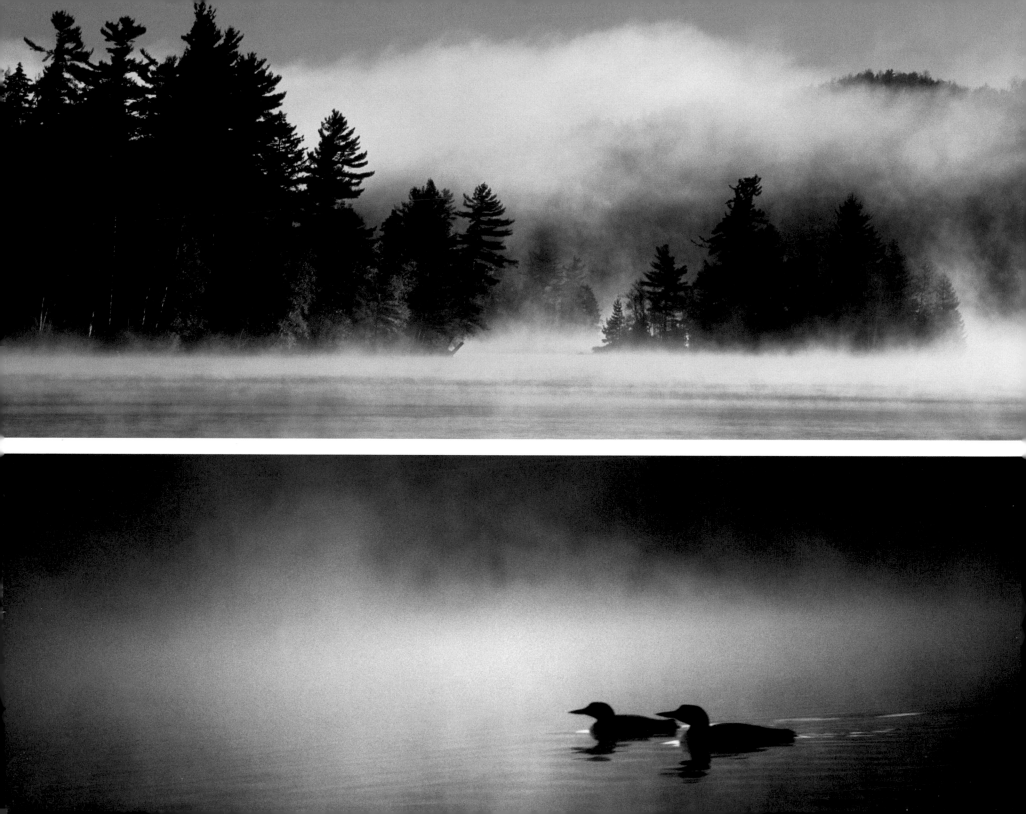

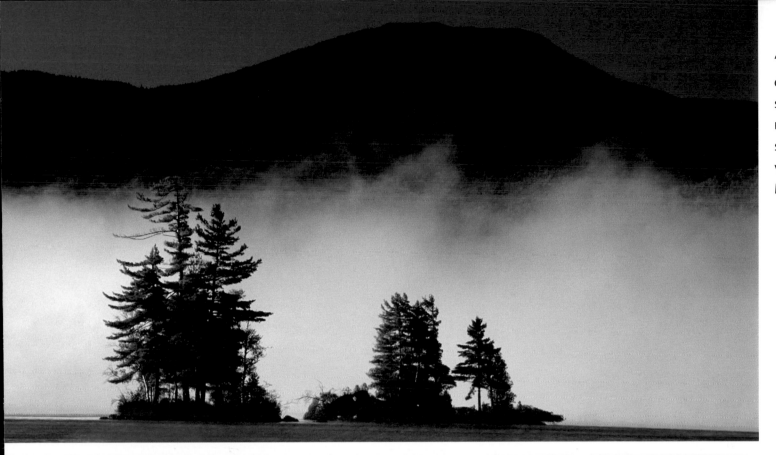

"The grand show is eternal. It is always sunrise somewhere; the dew is never dried all at once; a shower is forever falling; vapor is ever rising." John Muir

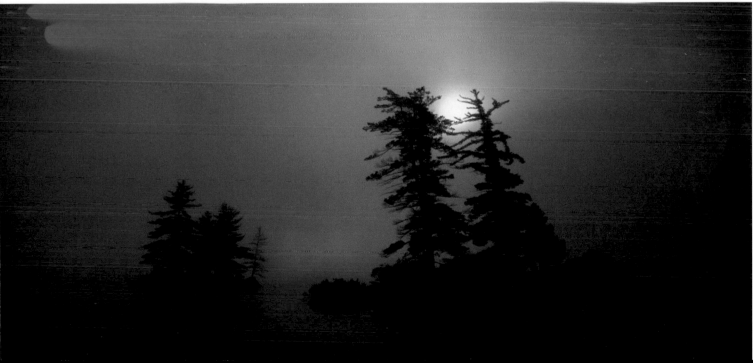

Mist, islands, and loons.

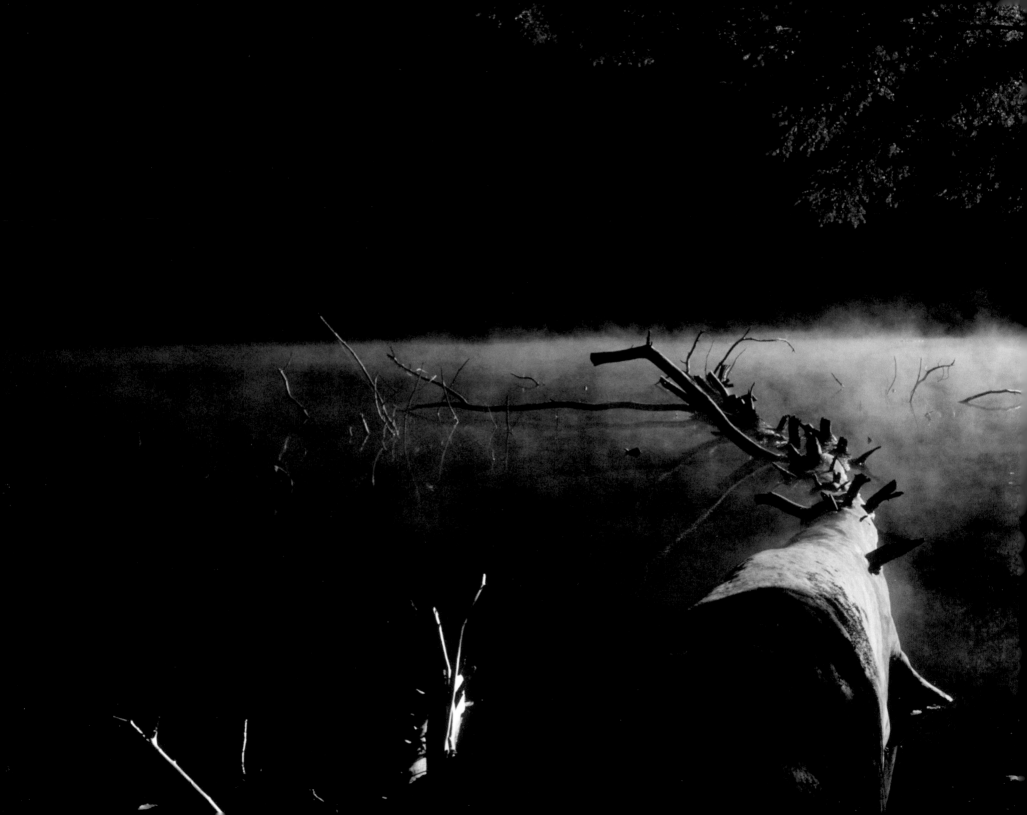

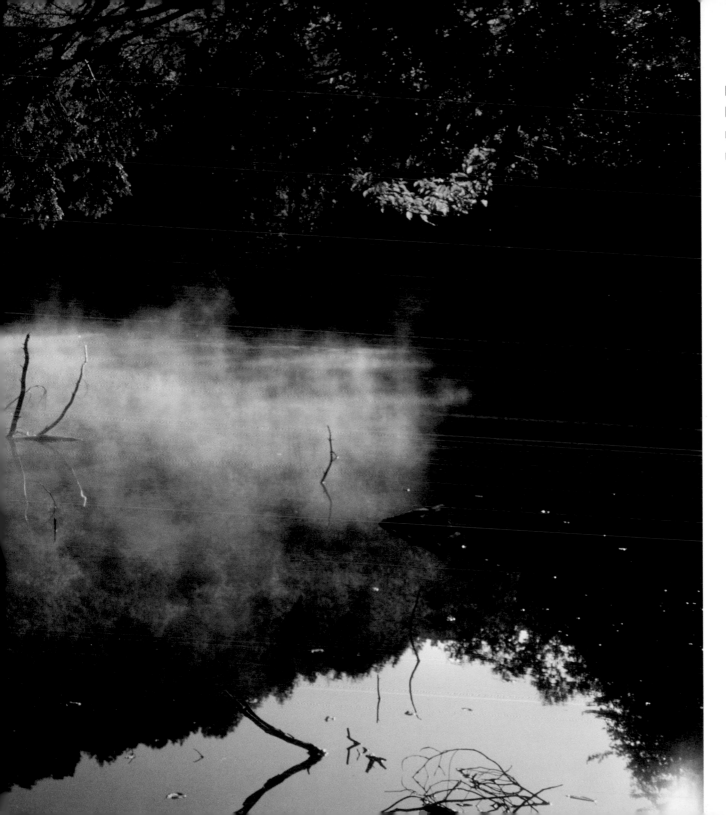

It is almost as though the landscape is brooding... not ready to give up the night, not ready to begin the day...

A fallen white pine in Mountain Pond, near Paul Smiths.

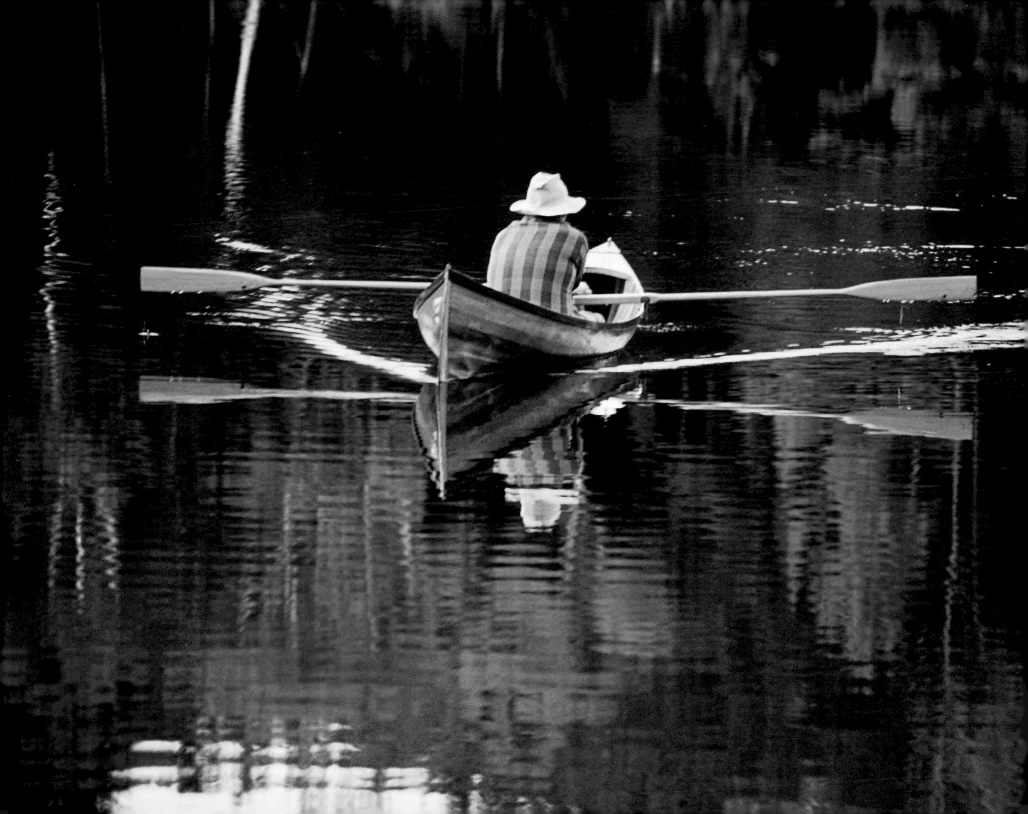

The Presence of Humans and Animals

To photograph Adirondack moments with people in them, a photographer must understand that a wilderness is a place where nature's ecosystem functions without the influence or encroachment of people. Using this definition as a guiding principle, a photographer must strive to let the wilderness dominate and show people in an unobtrusive way when they are included in photographs of wild places.

I have learned a great deal from Winslow Homer's watercolor paintings and the methods he used to blend people and the Adirondack landscape together. Homer's people always have a look to them that conveys a strong connection to a natural place. He also imparts a strong sense of wilderness to the landscape he includes in his paintings, which gives perspective and balance to the people and the natural environment.

When I photograph animals in the park, it is almost always an unexpected event. Wildlife usually venture out of the woods in early morning or late in the evening, when the light is not always suitable for a good photograph. Most of my wildlife photographs happen during the day when the light is good, and when I am able to set up my photography equipment quickly to take advantage of an unforeseen opportunity.

Dogs, horses, and chipmunks are usually more cooperative, but I still have to be patient. I like to capture domestic animals in a photograph when they are in interesting situations. Chipmunks love sunflower seeds, so they can be enticed to hang around for a long period of time, and sooner or later they will present a good pose for the camera.

Facing Page: Adirondack guideboat on Church Pond, near Paul Smiths.
Developed in the 1800s, the guideboat was fast on the water, light in the portages (called carries in the Adirondacks) and able to transport necessary camping equipment.
It did what the guides required and it enabled the dudes to enjoy the wilderness.

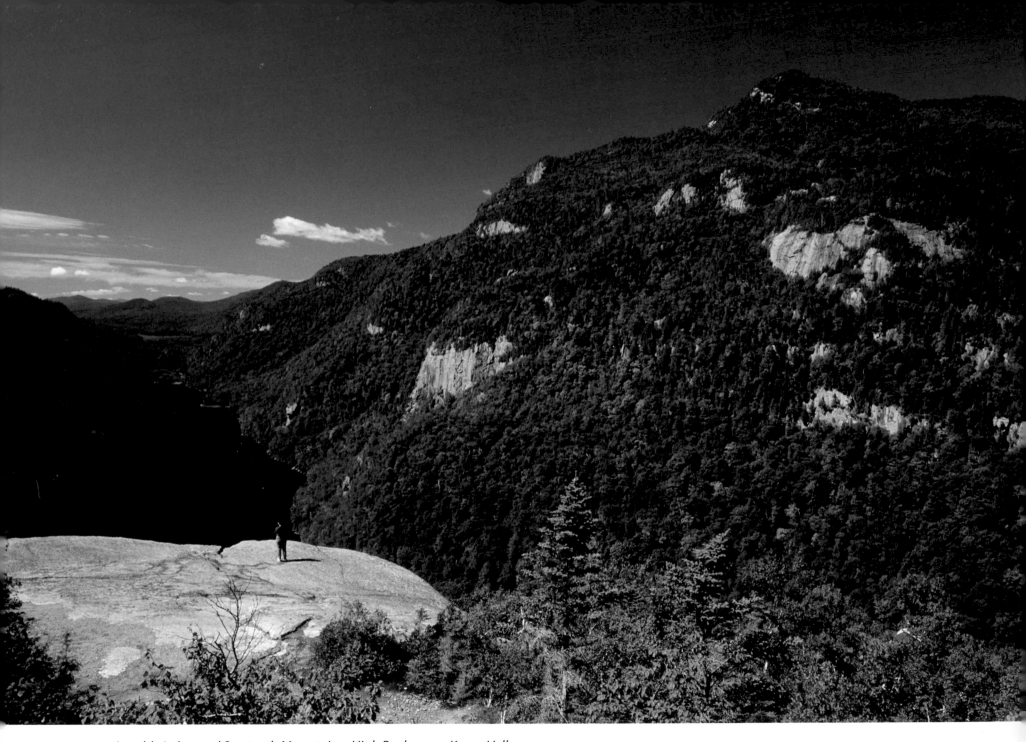

Ausable Lakes and Sawteeth Mountain – High Peaks, near Keene Valley.
Stand on a mountain and the world will be at your feet.

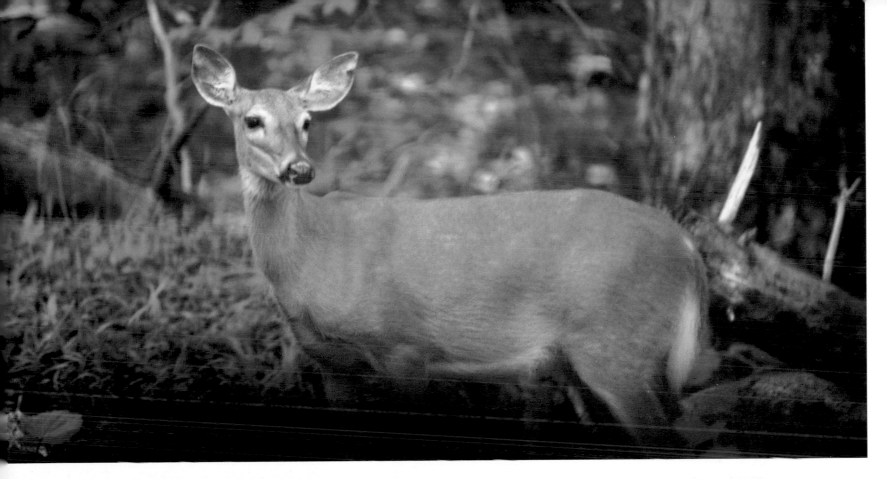

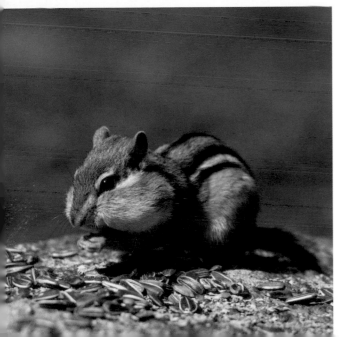

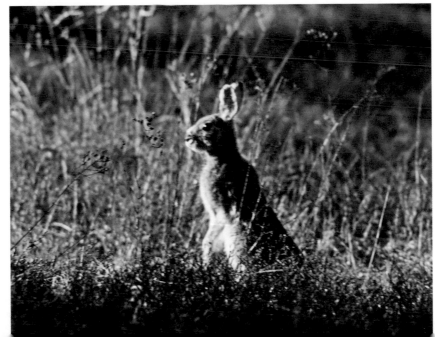

Whitetail deer, chipmunk, and a snowshoe rabbit. Seeing wildlife, whether big or small, is always special.

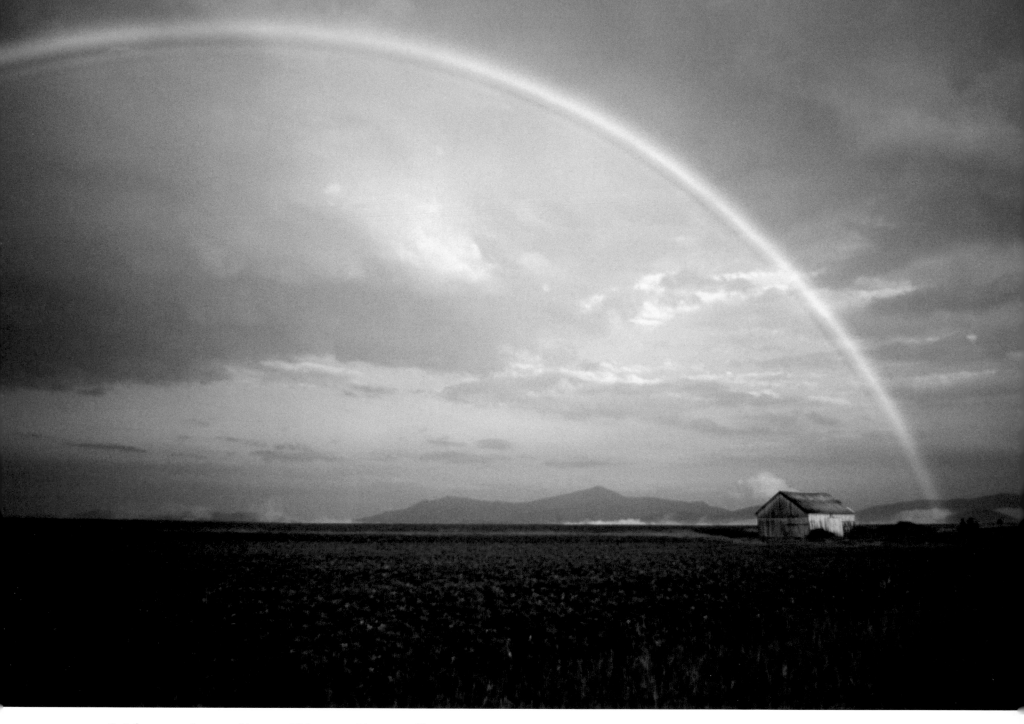

Rainbow over barn on Norman Ridge, near Vermontville.
"The true harvest of my life is intangible – a little star dust caught, a portion of the rainbow I have clutched." Henry David Thoreau

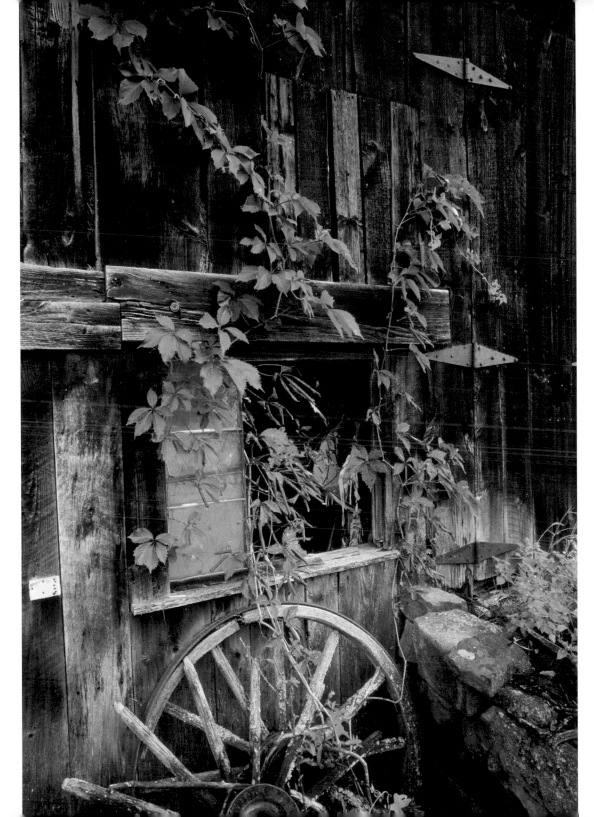

Exposed pine boards will weather into a beautiful gray, brown, orange and black.

Barn with window and wheel, near Wilmington.

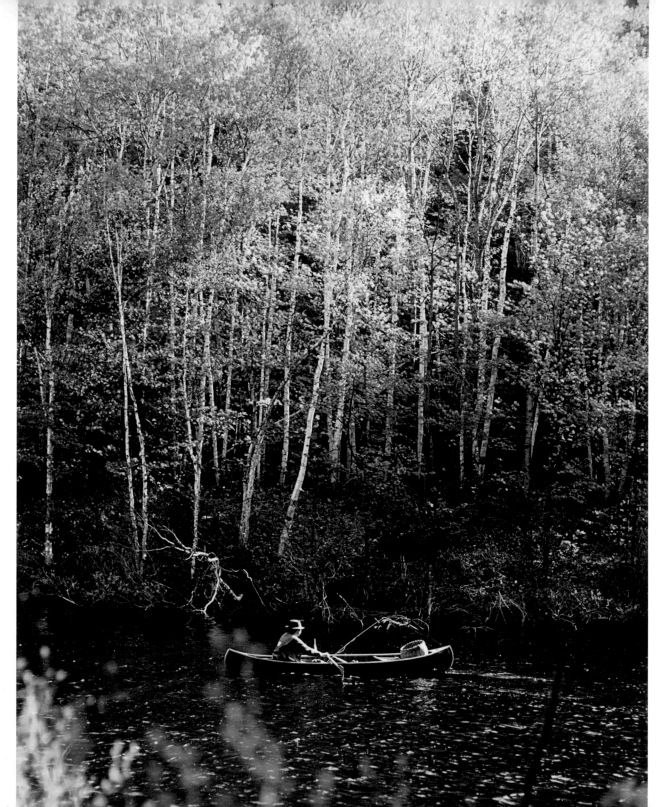

Fishing for brook trout
on ponds requires a
good canoe, the right
fly and some luck.

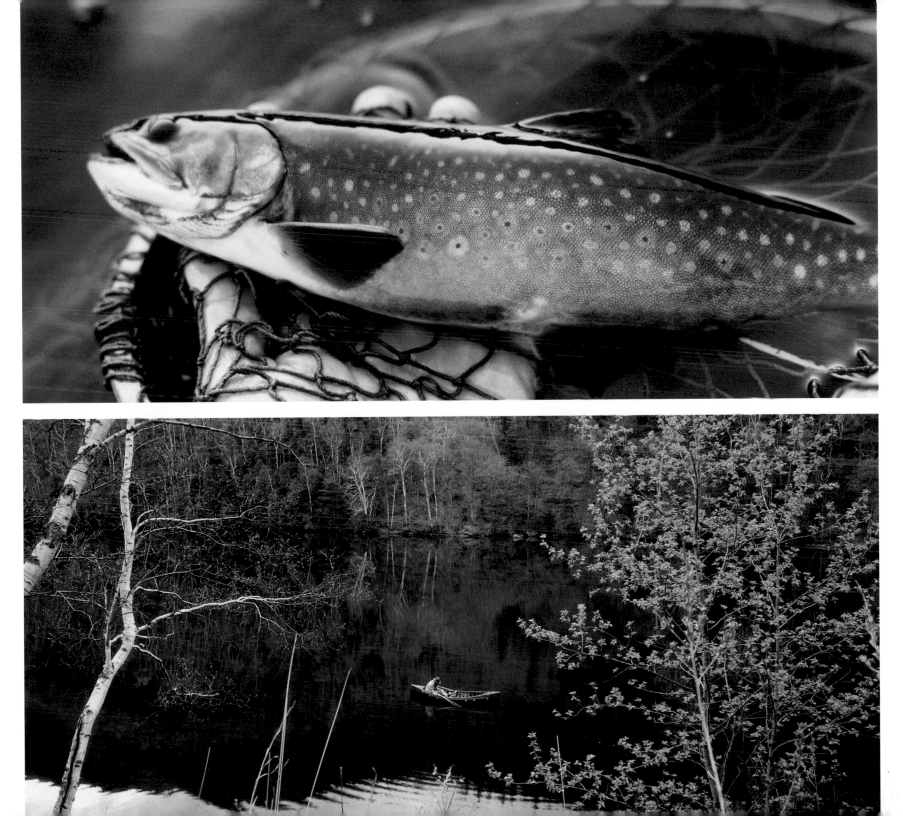

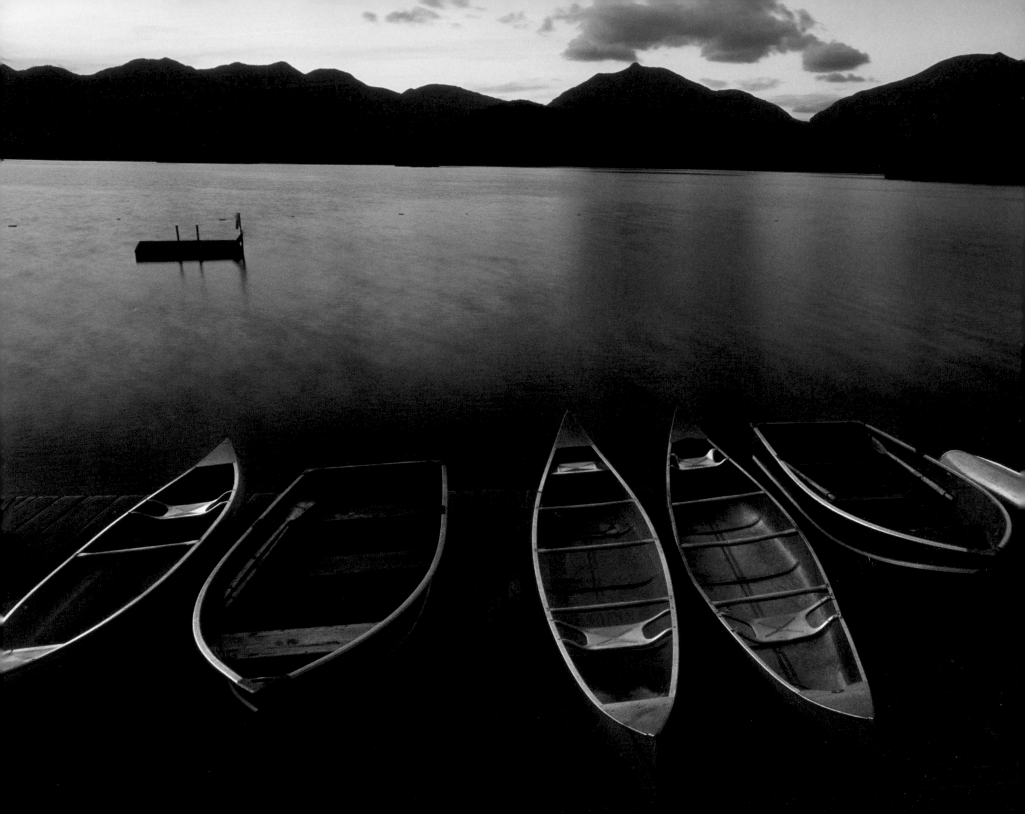

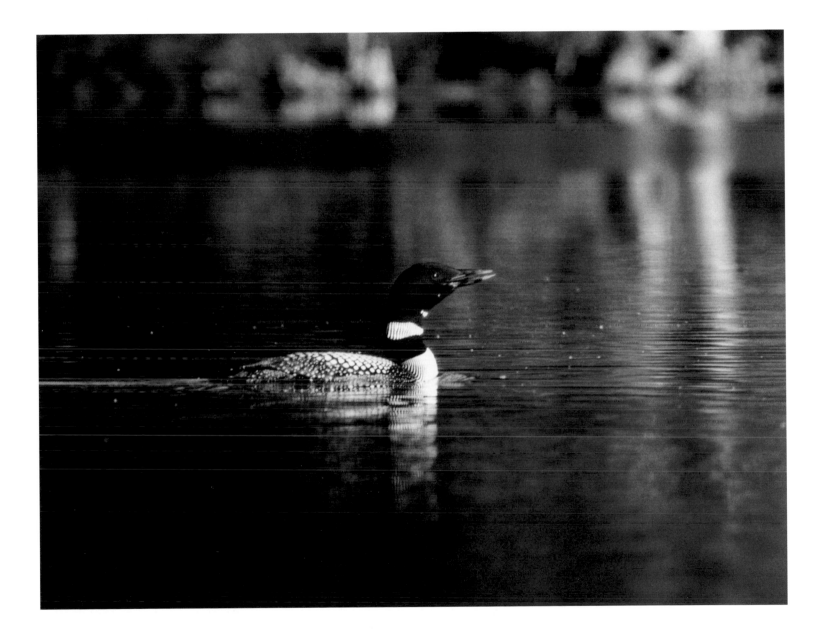

Above: Loon in evening light. Facing Page: Boats on dock at Elk Lake, near Newcomb.
Standing on a dock in the evening twilight, a loon calls and a feeling of wilderness and solitude emanates from the landscape.

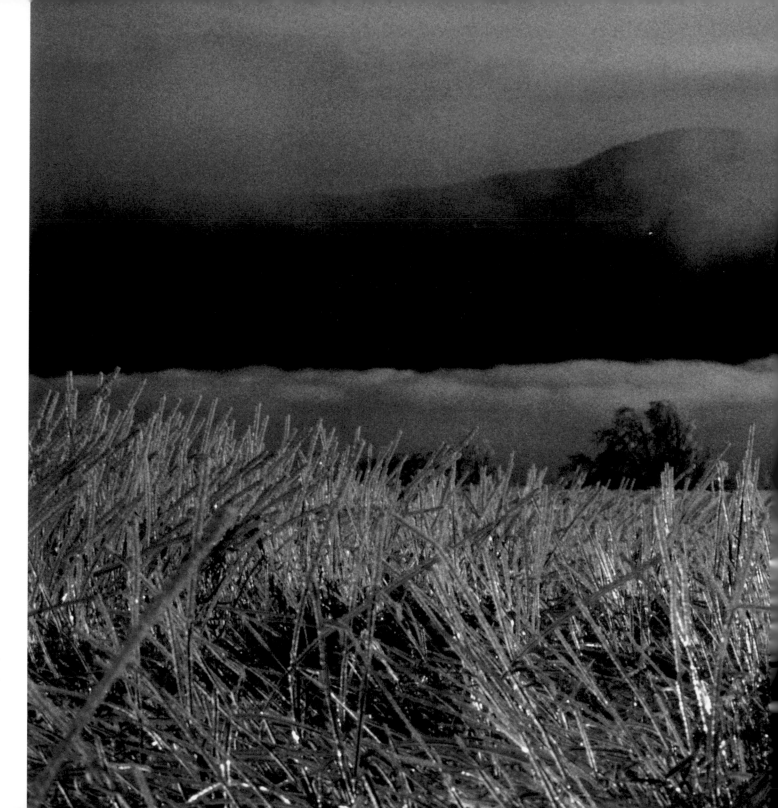

Weather can change a landscape many times and each change has its own beauty.

Barn on Norman Ridge after an ice storm, near Vermontville.

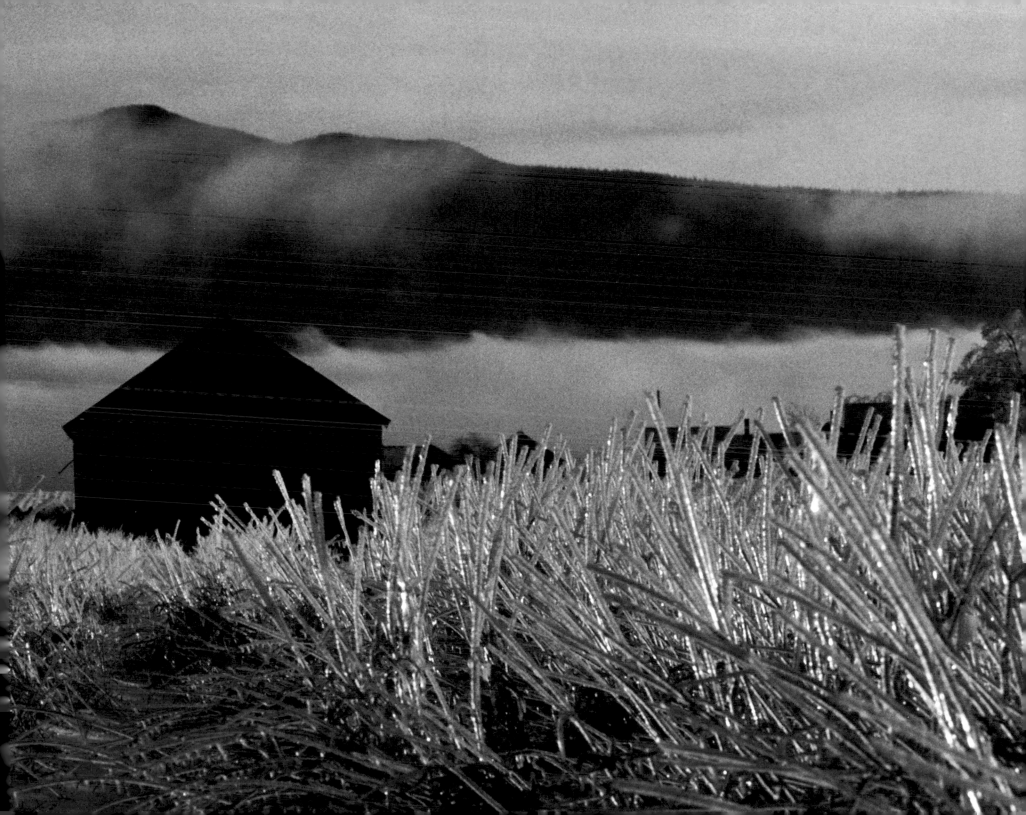

A horse, an old sleigh and the words "dashing thro' the snow, in a one horse open sleigh, o'er the hills we go, laughing all the way..." quickly come to mind.

Right: A horse finds spilled oats on the ground, near Paul Smiths. Facing Page: An old sleigh in a field, near Bloomingdale.

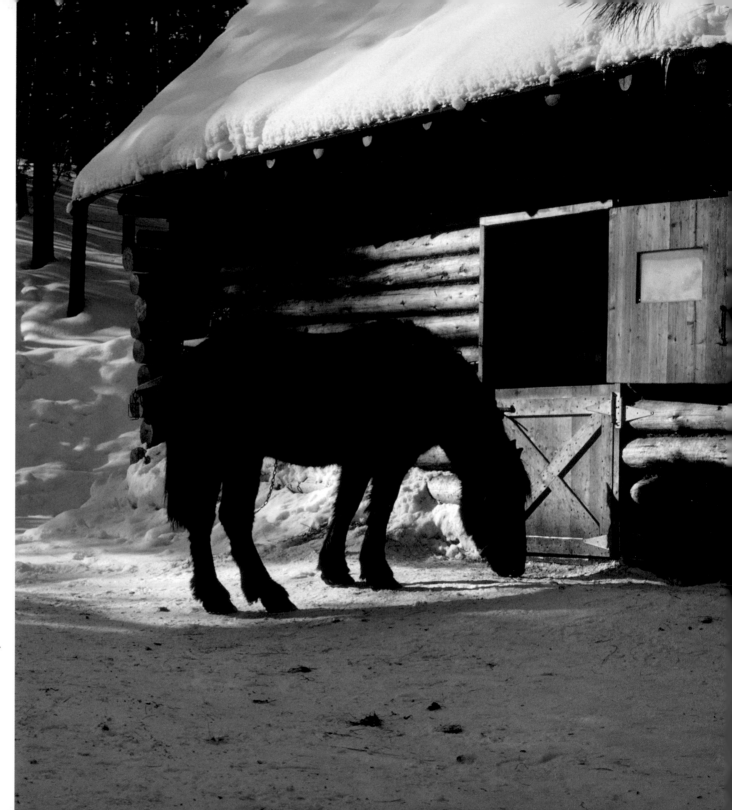

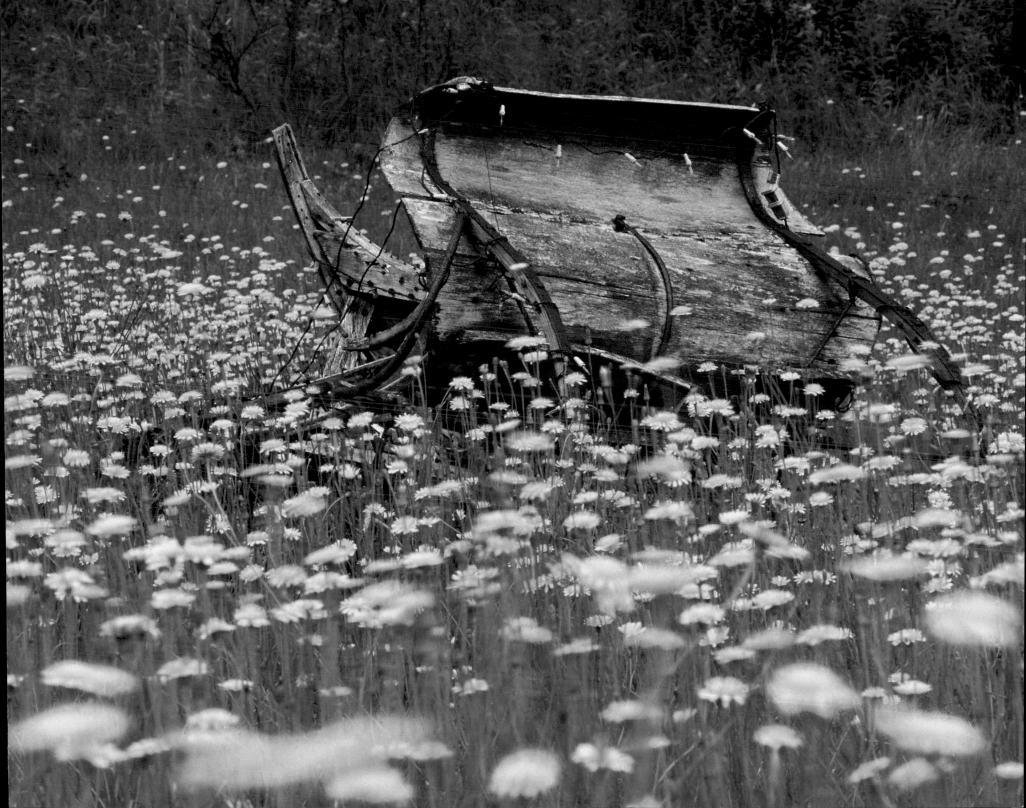

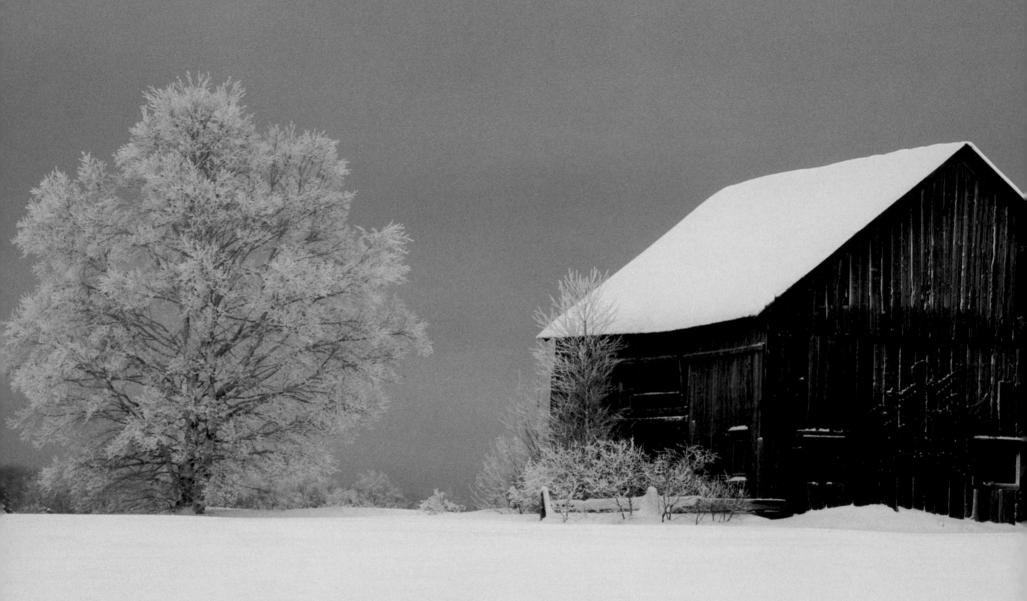

Above: Birch tree and barn, near Paul Smiths.
Facing Page, Top: Ice fishing on Osgood Pond, near Paul Smiths; Bottom: A golden retriever enjoys fresh snow, near Vermontville.

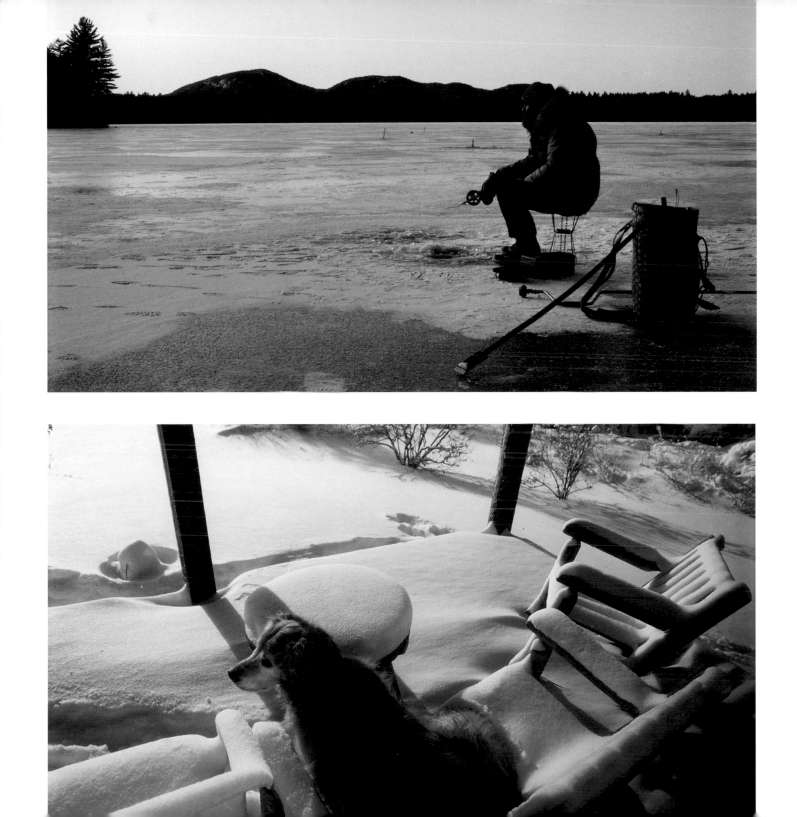

If the Adirondack Park remains unspoiled, moments like those shown here will continue to exist. These moments can help people to bond with nature and this will hopefully increase the likelihood that they will preserve this magnificent park for future generations.

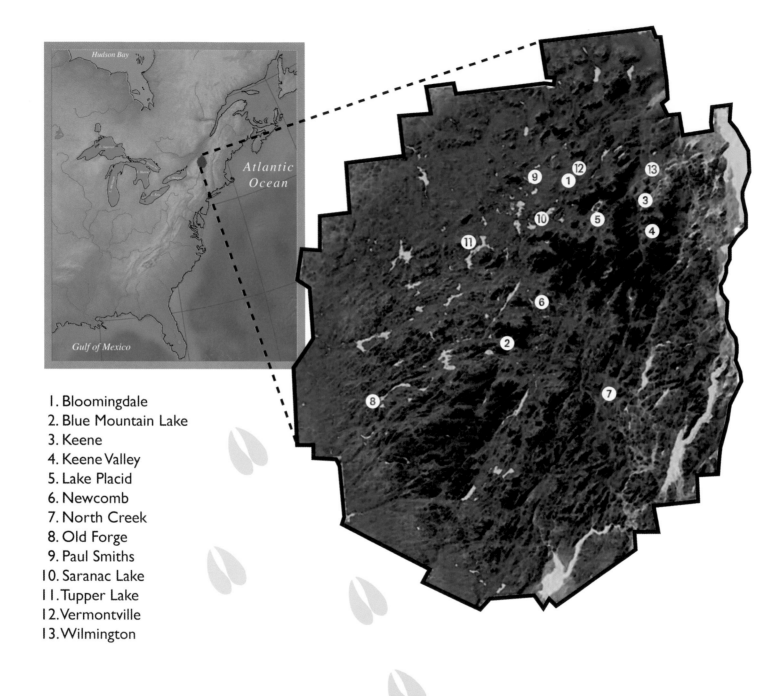

Hudson Bay

Atlantic
Ocean

Gulf of Mexico

1. Bloomingdale
2. Blue Mountain Lake
3. Keene
4. Keene Valley
5. Lake Placid
6. Newcomb
7. North Creek
8. Old Forge
9. Paul Smiths
10. Saranac Lake
11. Tupper Lake
12. Vermontville
13. Wilmington

TECHNICAL INFORMATION

Early photographs were taken with 35mm Olympus OM-2 and OM-4 cameras. The lenses used were a Tokina 17mm and Zuiko 28mm, 50mm, 135mm, 60–200mm Zoom, 300mm, 80mm macro and a 135mm macro. Later photographs were taken with a Nikon N90s camera. The lenses used were 24mm, 35–70mm Zoom, 80–200mm Zoom and a 300mm. The film used was Kodachrome 25 and 64 and Fujichrome Velvia 50. More recent photographs were taken with a Nikon D80 digital camera. The lenses used were Tokina 12–24mm DX Zoom, a Nikon 18–70mm DX Zoom, and my other Nikon lenses. My digital photographs were shot in RAW and processed in Photoshop CS2. A polarizer filter, a split density filter and warming filters were used in various situations. Cameras were mounted on a Bogen 3221 tripod to ensure photograph sharpness. In camera light meters were used, and exposures were adjusted as warranted by the subject and light conditions. Photoshop CS2 was used to optimize brightness, contrast, levels, saturation, color balance and sharpness.

A special thanks to Jim Bullard for his technical help.

Photo Credit – Jim Bullard

James Kraus has published photographs in *Adirondack Life, Gray's Sporting Journal, Adirondack Journal of Environmental Studies*, and Mike Kudish's book, *Upland Flora*. He has also authored and produced numerous filmstrips, slide shows, videos and articles on outdoor, marketing and educational themes. He taught forest recreation at Paul Smith's College for 30 years and incorporated photography into several of his courses. He and his wife live in the Adirondacks.